JAMES McNEILL WHISTLER

A GIFT FROM
PSI IOTA XI SORORITY
GAMMA THETA CHAPTER

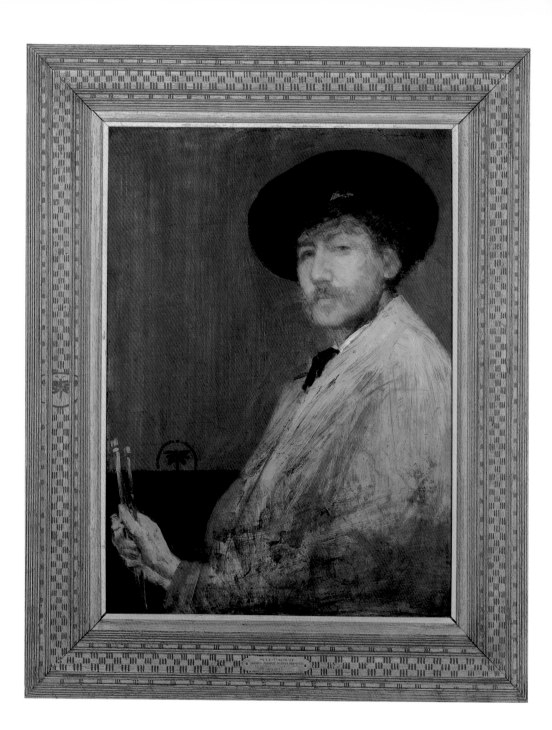

JAMES McNEILL WHISTLER

Robin Spencer

British Artists

Tate Publishing

Acknowledgements

I would like to thank Nicola Bion and Richard Humphreys for giving me the opportunity to write for the series. If the result has any distinction it is that this is the first book on Whistler to illustrate not just his pictures but also many of the frames which he designed and decorated for them. For this and detailed attention to the text I am very grateful for the excellent editing of Katherine Rose whose patience and skill have made the production process a pleasure; any mistakes remaining are all my own. Thanks go also to Sarah Tucker, who oversaw the production process, the persistent picture research of Sally Nicholls and the searching copy-edit of Jacqueline Harvey.

General Editor: Richard Humphreys
Senior Curator: Programme
Research, Tate Britain

First published 2003 by order of
the Tate Trustees
by Tate Publishing, a division of
Tate Enterprises Ltd,
Millbank, London SW1P 4RG
www.tate.org.uk
© Tate 2003

The moral rights of the author have been asserted

British Library Cataloguing in Publication Data
A catalogue record for this book is available from the British Library

ISBN 1 85437 486 9

Distributed in North America by
Harry N. Abrams Inc., New York
Library of Congress Control Number: 2003112066

Concept design James Shurmer
Book design Caroline Johnston
Printed in Hong Kong by South Sea International Press Ltd

Front cover: *Symphony in White, No.2: The Little White Girl* 1864 (fig.28, detail)

Back cover: *Nocturne: Blue and Gold – Old Battersea Bridge* c.1872–5 (fig.6)

Frontispiece:
Arrangement in Grey: Portrait of the Painter c.1872
Oil on canvas, 74.9 × 53.3 (29 × 21)
The Detroit Institute of Arts. Bequest of Henry Glover Stevens in memory of Ellen P. Stevens and Mary M. Stevens

Measurements of artworks are given in centimetres, height before width, followed by inches in brackets

All frames are original frames by the artist, unless otherwise stated

CONTENTS

1

DIFFERENCE

Look round a picture gallery, and you will recognize a Whistler at
once, and for this reason first, that it does not come to meet you. Most
of the other pictures seem to cry across the floor. 'Come and look at
us, see how like something we are!' Their voices cross and jangle like
the voices of rival sellers at a street fair. Each outbids his neighbour,
promising you more than your money's worth. The Whistlers smile
secretly in their corners, and say nothing. They are not really
indifferent; they watch and wait, and when you come near them they
seem to efface themselves, as if they would not have you see them too
closely. That is all part of the subtle malice with which they win you.
They choose you, you do not choose them.

(Arthur Symons, *Studies in Seven Arts*, 1906)

The case Symons makes for Whistler is perhaps not so obvious now as it was a
hundred years ago. Modern curators are more inclined to want their displays
to show how like rather than how different artists are, in order to demonstrate
their grasp of art history. But Symons's account is revealing as to how gallery
visitors, in search of something different then as now, may approach Whistler
when they come across him at the Tate. Whistler's painting has always been
recognised for the reticence of its colour and form, but the description of it
yielding itself up to the viewer makes it seem more like an encounter between
the sexes than the way in which we experience art today. Whistler himself
always referred to art as female, and to himself as her 'master'. 'She is a god-
dess of dainty thought ... selfishly occupied with her own perfection only –
having no desire to teach,' he said in his 'Ten O'Clock' lecture in 1885. Such a
gendered view of art would not have surprised educated men and women in
the nineteenth century. When Rodin was commissioned to make a memorial
to Whistler shortly after his death he chose an allegorical female figure, mod-
elled by Gwen John who had been a student of Whistler's, to represent his
friend's muse.[1]

On the other hand, Symons's metaphor of the street fair is an appropriate
one, because the art market and public exhibitions were so competitive that
artists from Turner to Whistler used every means at their disposal to outbid
their rivals for attention. In an age of rapidly changing fashions in art
Whistler could not afford to paint the same picture year after year. He always
had to adapt his art to suit the audience or exhibition he was painting for,
which was different from one decade to the next. The marines he painted
when he first settled in London in the 1860s are very different from the small
landscapes and seascapes he made out of doors in the 1880s and 1890s, which

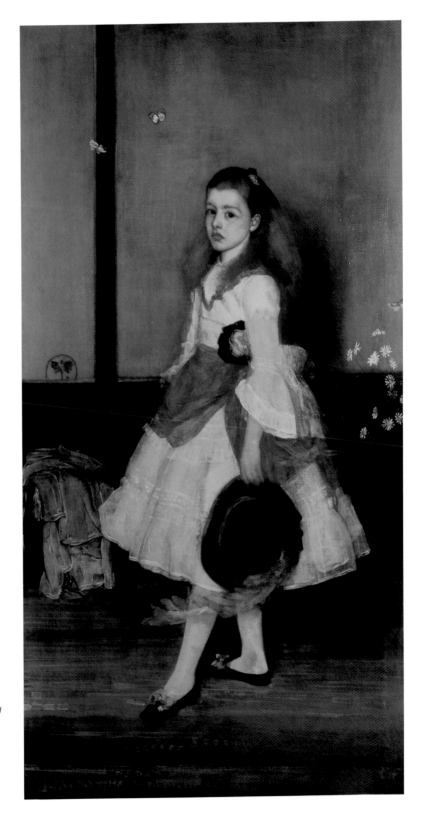

1 *Harmony in Grey and Green: Miss Cicely Alexander*
1872–4
Oil on canvas
190.2 × 97.8
(74⅞ × 38½)
Tate

are more like Impressionist paintings. In contrast, the low tonal range of most of his painting in the 1870s, including the nocturnes, could not look more different from modern French art of that decade. When Sickert first showed Degas his Whistler-influenced painting with its dark tones and muffled colours, Degas, no lover of plein air, complained, 'Oui! C'est bien! – mais tout ça a l'air de se passer la nuit!' (Yes! It's good! But it looks as if everything's happening at night-time!).[2] Whistler's later ambition

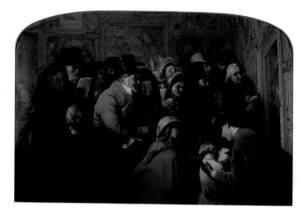

2 George Bernard O'Neill
Public Opinion 1863
Oil on canvas
53.2 × 78.8
(21 × 31)
Leeds Museum and Galleries (City Art Gallery)

for his portraits was that their brushstrokes should be practically invisible, like 'breath upon a windowpane'. This merging of dark figures with even darker backgrounds recalls Baudelaire's observation in his prose poem 'Les Fenêtres', that looking through an open window can never be as satisfying as looking at a closed one: 'In that dark luminous void life lives, life dreams, life suffers.'

The narrow tonal range and low key of Whistler's large formal portraits were generally very different from the way Victorian painters ran the full gamut of colour, seeking every effect and trick from dark to light. Such slick virtuosity could baffle a viewer as to how results like these, rivalled only by photography, could be achieved in paint. In fact Whistler called painting like this 'the coloured photograph kind of thing'. The brilliant flesh tones and deepest of black shadows in the usual 'picture of the year', he observed in 'A Further Proposition' (1887), always made a male subject look as though he 'stands out' from the frame. In this category he would have included some of the followers of John Singer Sargent, whose virtuoso technique had created a fashionable rival to his own more austere portrait style. However light the background, Whistler argued, the figure should always be shown standing further back 'within' the picture frame, at a distance equal to that from which the painter sees the model. 'Nothing could be more effortlessly inartistic,' he declared, 'than this brutal attempt to thrust the model on the hitherside of the window!' The reason for this, he explained, was that the public never sees nature as it really is but only 'unconsciously from habit, with reference to what they have seen in other pictures'. This makes them poor judges of both nature and art, including the art of the past which they think they know. Beside mediocre modern English art, even Velázquez is 'looked upon as mild', he concluded, 'beau bien sure, mais pas "dans le mouvement"' – or as some might say today – 'fine that's for sure, but not "cool"'.[3]

Whistler would have hated to be thought 'cool', and with some minor reservations would have settled for Symons's description of his work. Symons, a follower of Verlaine and Mallarmé, thought Whistler's painting was not like Victorian art at all, but had more in common with Impressionism and Symbolism, in which, he wrote, there were 'problems to be guessed at, as well as things to be seen'. It was often Whistler's custom to adopt a French appearance. Frank Harris remembered him in the 1880s wearing a stovepipe hat

with a straight brim which 'shouted at the passers-by, "I'm French, and proud of it!"'[4] As a frequent traveller in Europe, and a regular visitor to Paris, he had every opportunity to position himself for posterity in relation to the art of his time. From the early 1880s, when he began to exhibit in Paris again after an interval of more than a decade, Whistler gave every encouragement to French writers, in particular Théodore Duret and Stéphane Mallarmé, to consider him as the successor to Manet, who died in 1883. In 1898 he became President of the International Society of Sculptors, Painters and Gravers. Although the aim of the Society was the 'non-recognition of nationality in Art, and the hanging and placing of works irrespective of such consideration',[5] he arranged the first exhibition of modern art from Europe and the United States to make it clear that modern painting originated with Manet, Degas and himself. Today Whistler is still exhibited as part of the modernist project, in a room with white walls next to French art, or British or American Impressionist painting, on which he had a strong influence. But his art can also be integrated with Victorian painting of a less modernist persuasion, which he often tried to emulate, especially when he worked in London in the 1860s.

By the first decade of the twentieth century Whistler's painting was thought to display the characteristics of the art of up to three continents. In his defining history *Modern Art* (1908) Julius Meier-Graefe discussed Whistler's work in terms of four nationalities, 'The Englishman', 'The Frenchman', 'The Japanese' and 'The Spaniard'. And as recently as 1994 the catalogue of a Whistler exhibition at the Tate Gallery contained three essays which treated him as respectively a British, an American and a French artist.[6]

The American artist Eva Hesse (1936–70) used to say about her work: 'Don't ask what it means or what it refers to. Don't ask what the work is. Rather, see what the work does.' A hundred years earlier, in his statement known as 'The Red Rag', Whistler had said what he thought art should and should not do: 'Art should be independent of all clap-trap – should stand alone, and appeal to the artistic sense of eye or ear, without confounding this with emotions entirely foreign to it, as devotion, pity, love, patriotism, and the like. All these have no kind of concern with it, and that is why I insist on calling my works "arrangements" and "harmonies".' To illustrate his point he

3 Frank Holl
*Newgate – Committed
for Trial* 1878
Oil on canvas
152.3 × 210.7
(60 × 83)
Royal Holloway and
Bedford New College,
Surrey

used the picture he painted of his mother and called *Arrangement in Grey and Black*: 'Now that is what it is. To me it is interesting as a picture of my mother; but what can or ought the public to care about the identity of the portrait' (fig.34).

Whistler's use of musical terms to title his pictures, and his insistence on their formal properties rather than any associational issues they might suggest, places him firmly in the 'art for art's sake' camp. 'The Red Rag' was published in May 1878, the month Frank Holl's *Newgate* (fig.3) was the 'picture of the year' at the

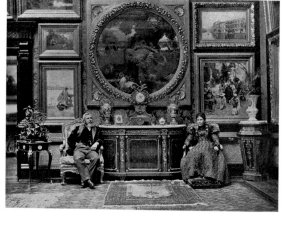

Royal Academy, where the portrait of Whistler's mother had been exhibited in 1872. Instead of the response Whistler would have preferred, the contemporary relevance of Holl's subject was the first thing that struck the viewer, for the care of prisoners and prison conditions were major social issues in 1878. *The Times* and the *Illustrated London News* compared Holl's picture to a scene from Dickens's *Old Curiosity Shop*, in which the homely Mrs Nubbles visits her innocent son Christopher in Newgate. In 'The Red Rag' Whistler described another of his paintings, *Harmony in Grey and Gold*, later called *Nocturne: Grey and Gold – Chelsea Snow* (fig.5), which shows a figure in the snow and a lighted tavern.

> I care nothing for the past, present, or future of the black figure, placed there because the black was wanted at that spot. All that I know is that my combination of grey and gold is the basis of the picture. Now this is precisely what my friends cannot grasp.
>
> They say, 'Why not call it "Trotty Veck" [Toby Veck in Dickens's story 'The Chimes'], and sell it for a round harmony of golden guineas?' – naively acknowledging that, without baptism, there is no ... market!
>
> But even commercially this stocking of your shop with the goods of another would be indecent – custom alone has made it dignified. Not even the popularity of Dickens should be invoked to lend an adventitious aid to art of another kind from this. I should hold it a vulgar and meretricious trick to excite people about Trotty Veck when, if they really could care for pictorial art at all, they would know that the picture should have its own merit, and not depend upon dramatic, or legendary, or local interest.[7]

Whistler had this manifesto-like statement of his artistic intentions published in *The World*, when he was preparing for his courtroom appearance against John Ruskin, whom he had sued for the libellous criticism of his painting in the summer of 1877. His insistence that art should be independent of human emotion shows that he was familiar with Ruskin's concept of the 'pathetic fallacy' in Book IV of *Modern Painters* (1856), where the latter warns of attributing to the inanimate object of painting feelings and emotional reactions

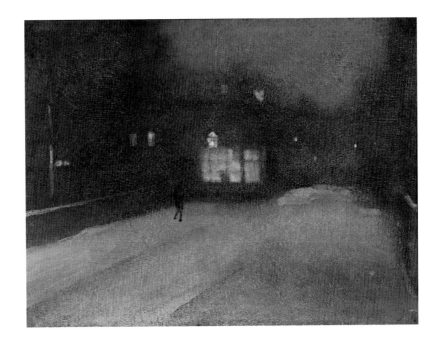

5 *Nocturne: Grey and Gold – Chelsea Snow* 1876
Oil on canvas
46.3 × 62.87
(18½ × 24¾)
Courtesy of the Fogg Art Museum, Harvard University Art Museums. Bequest of Grenville L. Winthrop

which characterise people. However, even without the sentimental gloss of a literary title, Whistler's lone figure trudging through the snow is not unlike a subject in Victorian art. Does this also make it an English picture?

We might think this is of secondary interest to the more important question of whether it is good art. Whistler would certainly have thought so, but in practice he faced the question every time he opened an art magazine or sent a picture to an international exhibition. Whenever he sensed anxiety about national identity, especially in Britain, he would use the issue of nationality, including his own, to exploit the situation to his advantage. In response to an absurdly exaggerated panegyric about the mediocre painter of religious subjects John Herbert (1810–90) he wrote in 1885: 'there is no such thing as English Art. You might as well talk of English Mathematics. Art is Art, and Mathematics is Mathematics. What you call English Art, is not Art at all, but produce, of which there is, and always has been, and always will be, a plenty.'[8]

Before we consider nationality, another aspect of 'The Red Rag' may be noted. The 'round harmony of golden guineas' his friends advised him to aim at provided more than a subtext for his argument. Why should the livelihood of the artist – and the market price of his picture – be decided by its subject and title rather than by its quality as painting? Yet in Whistler's day such values overwhelmingly prevailed, and brought great riches to artists willing to conform to them. Two of his paintings which most approximate to Symons's characterisation of Whistler as French, the impressionistic *Nocturne in Blue and Gold: Valparaiso Bay* and the very Manet-like *Arrangement in Grey: Portrait of the Painter* (frontispiece), once hung in the house of George McCulloch (fig.4), a millionaire who made his fortune in the Australian gold mines and was reputed to have spent more than £200,000 on contemporary art. Although Whistler is unlikely to be found in quite such a setting again, money

had no more respect for the national boundaries of art a hundred years ago than it has now. Like his French Impressionist contemporaries, Whistler had to compete with artists who painted very differently from him. By the 1890s when the price of his art rose, Whistler did everything he could to control the market in his work. He deeply resented collectors, including family and 'friends', who acquired paintings cheaply early in his career, and tried to profit from them when he was famous.

The case Whistler made for his art in 'The Red Rag' stakes out ground we still recognise today. The 'true' artist is the one who disdains popular acclaim, even though narrative painting is no longer the taboo it was for twentieth-century modernists. 'The vast majority of English folk,' Whistler said, 'cannot and will not consider a picture as a picture, apart from any story which it may be supposed to tell.' In this company he placed the popular Royal Academician W.P. Frith, the painter of *Derby Day* (fig.41), who appeared as a witness for Ruskin at the trial. In his autobiography of 1889 Frith wrote, 'It was just a toss-up whether I became an Artist or an Auctioneer.' In *The Gentle Art of Making Enemies* (1890) Whistler annotated Frith's statement with the reply: 'He must have tossed up.'[9]

The scorn Whistler felt for what Frith's kind of painting represented is also implied in Oscar Wilde's statement of 1883, that 'popularity is the only insult that has not yet been offered to Mr Whistler'.[10] It testifies to what in the history of art Gombrich called 'the fateful gulf between the artisan and the artist'. While the 'true' artist despises vulgar taste, and works for a refined minority, the craftsman and artisan have no choice but to work to the laws of demand and supply. This division in the market has an analogy with the academic hierarchies which Sir Joshua Reynolds upheld in his *Discourses* (1769–90), a copy of which Whistler's father gave him when he was 14. Whereas the high ideals of history painting can be understood only by the educated elite, genre and landscape subjects studied from nature appeal to the masses. The situation prevailed until the nineteenth century when, among other factors, industrialisation and a newly literate audience for art saw a revision of Reynolds's categories, as well as the craft tradition being lost through the mass manufacture of goods by the machine. William Morris, influenced by Ruskin, made an influential case for what he called the 'lesser arts', by raising the status of the decorative and applied arts, and persuading the middle classes to pay for them accordingly.[11]

In spite of William Morris's achievement, society today arguably still values the work of the artist or sculptor more highly than it does that of the craftsman and artisan – or the commercial artist whose job is to help to sell as many products as possible. (It is not the mission of the Tate to acquire a representative collection of their work.) This does not mean that artists and sculptors, from Picasso to Paolozzi, have not valued the work of 'popular' artists and artisans, or profited from their skills. Throughout the twentieth century there has been a steady crossover between 'fine' and 'applied' art, and between 'high' and 'low' subjects, which is still a starting point for artists today, a century after Whistler's death in 1903. A moment in the Whistler–Ruskin trial suggests why this issue assumed the importance that it did.

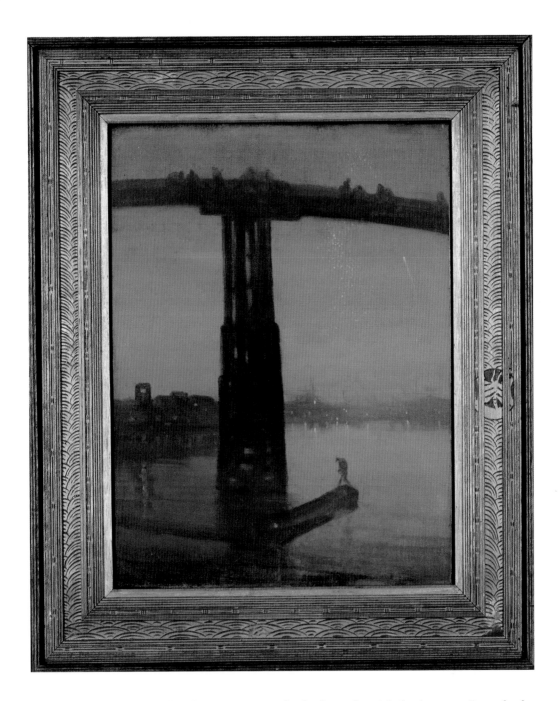

6 *Nocturne: Blue and Gold – Old Battersea Bridge* c.1872–5
Oil on canvas
68.3 × 51.2
(26⅞ × 20⅛)
Tate

When he cross-examined Whistler at the trial, the Attorney-General, who represented Ruskin, asked him what the 'peculiar dark mark' was on the frame of Battersea Bridge, the picture he called *Nocturne in Blue and Silver*, which is now in Tate Britain, and also known as *Nocturne: Blue and Gold – Old Battersea Bridge* (fig.6). Whistler explained it was his monogram signature in the form of a butterfly which he often placed on the frame as well as the canvas. Whistler's replies to Ruskin's Counsel were that it was 'part of the scheme

of the picture'; 'It balances the picture'; 'The frame and the picture together are a work of art.[12]

Decorating picture frames, furniture and walls, or treating the room as an ensemble, were not new. The Pre-Raphaelite artists and their associates, Dante Gabriel Rossetti, Ford Madox Brown and Burne-Jones, pioneered it, and William Morris made it a commercial success, but Whistler was the first painter to blur the traditional distinction between the work of the artist and that of the craftsman, so that it is often unclear in his painting where the work of one ends and the other begins. The Attorney-General's question at the trial, although a disingenuous ploy, nevertheless reflects the sincerely held view of Ruskin, who in writing to his solicitor to defend his criticism of Whistler, said he believed it was his duty to 'rank an attentive draughtsman's work above a speedy plasterer's'.[13]

The motif of the bridge in *Nocturne: Blue and Gold – Old Battersea Bridge* was derived from a Japanese print by Hiroshige. Whistler taught his Chelsea boat-builder assistants Henry and Walter Greaves, who helped him in the studio, to paint the blue-on-gold wave decoration on his frames. The pattern, together with his butterfly signature, was also derived from Japanese prints and pattern books he either owned or knew from the South Kensington Museum. The

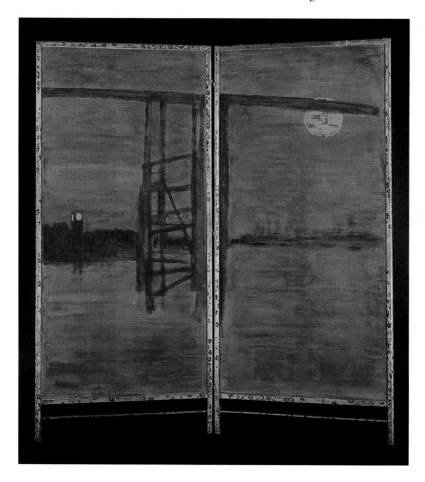

7 *Blue and Silver: Screen with Old Battersea Bridge*
c.1872
Distemper and gold paint on brown paper laid on canvas and stretched on back of silk
195 × 182
(76¾ × 71⅝)
(fully open, in frame)
Hunterian Art Gallery, University of Glasgow

14

8 Design for the
decoration of
Aubrey House
c.1873–4
Charcoal and
gouache on brown
paper
18.2 × 12.6
(7¼ × 5)
Hunterian Art
Gallery, University of
Glasgow. Birnie
Philip Bequest

bridge, with Chelsea Church and the moon, also appear on the two-part screen he painted at the same time (fig.7). Like the painting, the screen also has its frame decorated with a design of blue on gold. Is it still a piece of furniture, or has it become a painting?

While Japanese prints and artefacts were considered instructive, when they were first seen in London in 1862 they were admired as products of ingenious and curious design made by a feudal society, without the 'refinement' of Western art. Their everyday subject matter, brilliant colour and inventive compositions influenced Impressionist painting and played a major role in the decorative arts of the time. But Whistler, an American, was the first to 'graft on to the tired stump of Europe, the vital shoots of Oriental art', by realising that the design principles of Japanese art were relevant to painting as well as decoration. In his 'Ten O'Clock' lecture he made the claim, a radical one in 1885, of ranking the work of Hokusai alongside the Elgin marbles and the paintings of Velázquez.[14]

The background to Whistler's portrait *Harmony in Grey and Green: Miss Cicely Alexander* (fig.1) resembles the minimal colour schemes he designed for the walls of Aubrey House, for which it was painted (fig.8). Their abstract appearance has led some art historians in the modernist period to think of Whistler as a forerunner of Rothko.[15] While Whistler was later to be admired by some of the American Abstract Expressionists, in the 1870s these wall designs would have been seen as resembling a seascape or a beach scene. Illusionistic effects, which had been a feature of wallpapers exhibited at the Great

Exhibition in 1851, had been superseded by designers, like Morris, who respected the flatness of the wall surface. Whistler chose the most appropriate subject in nature, which he had already treated in painting, to meet his decorative requirements. The artist 'does not confine himself to purposeless copying, without thought', but in the blade of grass or in a butterfly's wing, he said in the 'Ten O'Clock', 'finds hints for his own combinations, and thus is Nature ever his resource, and always at his service'. He made no distinction between easel painting and decoration.

The same thinking lay behind his choice of the motif for the dining room decoration he called *Harmony in Blue and Gold: The Peacock Room* (fig.9). Nearly every surface of the room is covered with an intricate pattern of blue and gold based on the tail feathers of the peacock, which was a design icon of the Victorian pattern book in the 1870s. Whistler certainly intended an effect of luxuriant richness, rather than a sensation of austere abstraction. When he visited St Mark's in Venice early in 1880, he wrote to his sister-in-law that the Byzantine splendour of the gold mosaics in the dome were not as 'complete' as the ceiling of the Peacock Room.[16]

The mixture of painting and decoration again raises the question of Whistler's intentions. A visitor to his house in Lindsey Row at the time of the Peacock Room remembers being shown into a room 'barely furnished, very pleasant, looking towards the river. There were little heaps upon the floor of what I took to be scarves and clothes impatiently flung aside. He called out to me to walk carefully, these were decorations, and not to move them – "people decorate their ceilings," he said, "they hang their walls with ornament, why should they not decorate their floors; this is what I am doing".' Some of the designs he made for matting probably date from this time. The incident can be seen as an example of Whistler's modernity, even an anticipation of Conceptual art, but it also suggests the *gesamtkunstwerk*, Wagner's complete work of

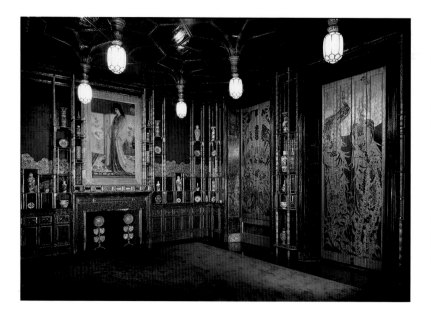

9 *Harmony in Blue and Gold: The Peacock Room* (view of north west corner) 1876–7 Oil paint and gold leaf on leather, canvas and wood 425.8 × 1010.9 × 608.3 (167⅝ × 398 × 239½) with *La Princesse du pays de la porcelaine* 1863–5, above the fireplace Freer Gallery of Art, Smithsonian Institution, Washington, DC; Gift of Charles Lang Freer

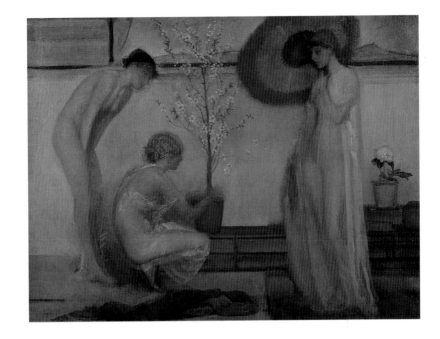

10 *Three Figures:
Pink and Grey* (from
the 'Six Projects')
1868–79
Oil on canvas
139.1 × 185.4
(54¾ × 73)
Tate

art, his 'Art-Work of the Future' (1850), which had become part of the avant-garde vocabulary by the 1860s. The Peacock Room, with its paintings and intensely worked surfaces, offered Whistler the chance to fulfil his ambition for decorative art on a grand scale. Wagner's music had suggested to Baudelaire that sounds and colours were interchangeable, a concept known as synaesthesia, the idea that a sense impression of one kind could be produced by the stimulation of another. Whistler and his artist friends, Henri Fantin-Latour, Alphonse Legros and Edouard Manet, were in Paris at exactly the right time to be the direct heirs to these ideas, which were also reflected in the musical titles Whistler chose to use for his paintings.[17]

According to the American artist Otto Bacher, Whistler's 'most ambitious desire was to paint a grand concerto-like picture with the title "Full Palette" – "just as in music," he explained, "when they employ all the instruments they make it 'Full Band'. If I can find the right kind of thing I will produce a harmony in color corresponding to Beethoven's harmonies in sound."' The painting that became a receptacle for these Romantic concepts, and the culmination of all his ambitions as a decorative figure painter over several decades, was the composition known as *Three Figures: Pink amd Grey* (fig.10), or *Symphony in White and Red*, which was begun in 1868 as one of the 'Six Projects' (see also fig.33). Many studies and variants are recorded. The version in the Tate Collection was probably a copy Whistler made of the original when he dismembered it, just before he left for Venice in the autumn of 1879, and was anxious not to have his pictures fall into the hands of his creditors, particularly F.R. Leyland. Before Whistler fell out with him over payment for the Peacock Room, the plan had been that *Three Figures* should hang on the south wall of the dining room, facing his *La Princesse du pays de la porcelaine* at the other end (see fig.9). Had it done so, the Wagnerian dimension to Whistler's

scheme would have been complete with the inclusion of an explicit reference to music. The original frame of *Three Figures* had a blue on gold pattern, very like that of *Screen: Blue and Silver*, and on it was inscribed the first bars from the third of Schubert's *Moments Musicaux* (Allegro Moderato in F minor), Opus 94. The conceit would doubtless have appealed to Leyland, an amateur pianist, who had suggested 'nocturne' to Whistler as a title for his pictures.[18]

Three Figures: Pink and Grey draws on a combination of several traditions. The subject of girls in a garden is from Kiyonaga, several of whose prints Whistler owned, and the decoration on the frame is also Japanese; but the girls' drapery and poses are Western, in particular the crouching figure which is based on a pose in Classical sculpture. The composition is very similar to one by Albert Moore, whose Neo-Classical figure subjects were then fashionable in British art. In the mid-1860s Whistler immersed himself deeply in this tradition, which, after Ingres died in 1867, seemed in danger of being lost to Western art. He never became a purely decorative painter like Puvis de Chavannes; it was neither his ambition nor within his powers to do so. But for the rest of his life he continued to quote from the Classical tradition, and *Three Figures: Pink and Grey* provided him with a succession of subjects for oil paintings, watercolours and pastels in the 1880s and 1890s.

Harmony in Blue and Gold: The Little Blue Girl (fig. 11) combines in one image all the artistic 'differences' Whistler adopted in his art which we have been considering here. The frame is decorated and signed with a butterfly, but the painting is not; the pattern on the frame is repeated in the matting at the bottom edge of the picture; and nature in the form of flowers issues from a ceramic pot. In the background is the fictive representation of another item of decorative art, the screen, with the gold moon which had been painted some twenty years earlier. Whistler regarded the nude subjects of his later years as embodiments of a beauty concealed to all but the artist, which only the artist could reveal to the viewer. For Whistler the meaning of *Harmony in Blue and Gold* lay in the gesture of the little girl who opens and closes her drapery for the viewer. She is a metaphor for the concealment and revelation of art.

Harmony in Blue and Gold occupied Whistler for the best part of a decade before his death, and represents his last thoughts on the universality of art. He had next to no interest in modern American art, but if he ever made an American painting it was *Harmony in Blue and Gold*. He painted it for Charles Lang Freer of Detroit, who had begun to collect Whistler's work, with his assistance: 'I wish you to have a fine collection of Whistlers!! perhaps *The* collection –,' he wrote to Freer in 1899. Freer's attraction for Whistler was that he bought his latest work directly from him; only after his death did he assemble a representative collection. Freer was also a collector of Chinese and Japanese art. Although Whistler was no longer an influence on modern American art when the Freer Gallery eventually opened in Washington, DC in 1923, with its displays of Asian art and Whistler, which included the Peacock Room, both collector and artist had consciously wanted to make a contribution to American cultural history.[19]

Had the history of the twentieth century upheld Whistler's internationalist vision for the art of the future, Tate Modern would have come into existence

11 *Harmony in Blue
and Gold: The Little
Blue Girl* 1894–1903
Oil on canvas
74.7 × 50.5
(29⅜ × 19⅞)
Freer Gallery of Art,
Smithsonian
Institution,
Washington, DC;
Gift of Charles Lang
Freer

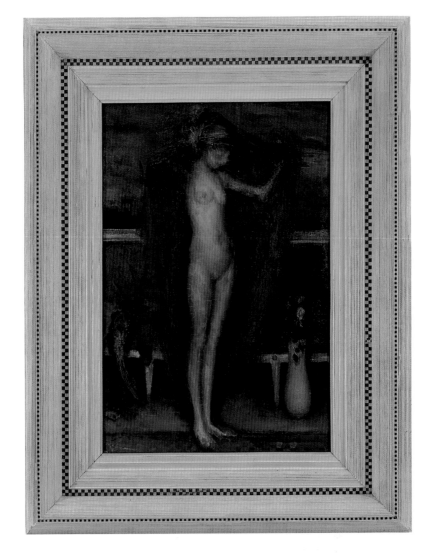

without the need for Tate Britain, where nationhood is the defining factor. Yet the question is more than hypothetical. For Whistler the National Gallery in Trafalgar Square was not good enough, not because its name implied any imperial claim to omniscience, but because some of its exhibitors were still alive. He preferred the Louvre where all the competition was safely dead. Unlike Turner, who left his work to the nation, Whistler took advantage of market forces to have it exported from the country. To see a representative collection of his work today it is necessary to visit the United States and Scotland. His sister-in-law gifted the entire contents of his studio, including his archive, to the University of Glasgow, which had given him an honorary degree the year he died. From his viewpoint at the end of the nineteenth century Whistler saw that the twentieth century would belong to the United States of America.

2

LIKENESS

In its likeness as well as its difference, Whistler's art was an eclectic mixture of strongly held values as conflicting as those which had formed his own ancestry. The complexity of his position with respect to his American nationality and his hostility to the British, whom he referred to as the 'Islanders', cannot be underestimated. His birthplace, in 1834, was the industrial cotton-spinning town of Lowell, Massachusetts. It had been founded as recently as 1783 by Kirk Boott of Derby, for whom Whistler's father worked as engineer of locks and canals. Memory of the mother country was less than three generations old before Whistler returned to claim his patrimony. Before then, his mother had assiduously maintained contact with her British relatives for professional and family reasons, links which would later be strengthened by marriage. As a boy he stayed with these relations on his long transatlantic trips and quickly came to understand their social values. These experiences also provided him with valuable contacts, particularly in Lancashire, when he became an artist.[1]

The persona Whistler presented to the world embodied the founding myth of freedom, the plucky underdog fighting the imperial power. But the Whistlers were transatlantic Britons who became American patriots. On both sides of his family there was a tradition of pragmatic colonialism. Like his two grandfathers, who first fought for the British in the revolutionary wars before joining the American army, Whistler had a natural instinct for ending up on the winning side. His father, George Washington Whistler, railroad engineer and graduate of the United States Military Academy at West Point, was probably descended from English settlers in Ulster. Whistler later made selective use of his Irish ancestry to aggravate his host nation, knowing how Ireland had become such a political thorn for Britain. The family of Whistler's

12 *Render unto Caesar the things that are Caesar's*, from 'St Petersburg Sketchbook' 1844–8 Pencil, watercolour, wash, ink crayon and pastel on white wove paper bound in purplish-brown cloth
14.2 × 20.4 (5⅝ × 8) Hunterian Art Gallery, University of Glasgow

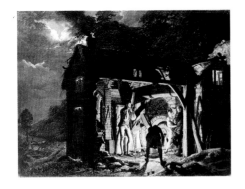

mother, Anna McNeill, had emigrated in 1746 from the west of Scotland to North Carolina where she was born in 1804. Her father, Dr Daniel McNeill, kept slaves. Born in America, he had trained in Edinburgh as a doctor, which was the profession of Whistler's younger brother who also made his career in London. To his mother's austere but indulgent Episcopalianism Whistler owed his retributive zeal, and the Bible provided him with some of the effects of syntax and the ecclesiastical allusions he sought in his polemical writing.

In 1843 George Washington Whistler took his family to Russia, where he supervised the building of the railroad from St Petersburg to Moscow for Tsar Nicholas I. Between the age of 9 and 14 Whistler learned French and took his first formal lessons in art at the Imperial Academy of Fine Arts, where he was taught the Neo-Classical principles of drawing and design required for history painting. When he became a student in Paris he more or less rejected the kind of art his Russian training represented, but its principles stood him in good stead when he wanted to return to them later. Drawings after the antique and studies for biblical subjects are to be found among the surviving observational sketches of Russian life he made in St Petersburg (fig.12). They may reflect the encouragement given to him personally by Sir William Allan, President of the Royal Scottish Academy, who was then in St Petersburg to paint scenes from Russian history for the Tsar. At this time Whistler also became familar with the engravings of Hogarth, whose painting technique he claimed, much later in life, was similar to his own.[2]

Whistler's experience of art in Russia had further significance. In the imperial collections were two spectacular paintings by Joseph Wright of Derby, the nocturnal scenes of Mount Vesuvius erupting, and *An Iron Forge viewed from without* (fig.13). Whistler's own atmospheric etching of a forge of 1861 (fig.14), probably based on his knowledge of Wright's picture or the engraving after it, reflects his awareness of his own kinship, through Francis Seymour Haden, with the great eighteenth-century painter of the Industrial Revolution. Haden became Whistler's brother-in-law when he married his half-sister, Deborah, in Preston, Lancashire, in 1847, and Haden's grandfather, who came from Derby, was related to Joseph Wright by marriage. The Hadens had another link with the Whistlers. Haden's aunt was the widow of Kirk Boott of Derby, who had been Whistler's father's employer in Lowell, Massachussetts. The chain of events that brought Whistler back to England to make his liveli-

hood as an artist was forged in the heartland of the Industrial Revolution in the middle of the eighteenth century.

The death of George Washington Whistler from cholera in St Petersburg in 1849 left the family poor. Any idea Whistler had of studying art in Europe had to be set aside when the family returned to the United States, to live in reduced circumstances in Pomfret, Connecticut, where he and his brother went to school for two years. That he might one day return to Britain, and the family fortunes change, had been encouraged by his half-sister's marriage. Haden was a London surgeon with artistic ambition and connections at court. He was also an amateur etcher, with a growing collection of old master prints, and played an important role in Whistler's art education. Their relationship was complicated by their rivalry as etchers, and personal incompatibilities eventually brought it irrevocably to an end in 1867. Haden later rose to become founder and President of the Society of Painter-Etchers. Whistler would have nothing to do with it, but Haden is reputed to have said that if he had to sacrifice either his Rembrandt or his Whistler prints, he would keep the Whistlers. Meanwhile, Whistler's brother-in-law brought him into precocious contact with the London art world. Before his return to the United States in 1849, when he was 15, he had been to Hampton Court to see the Raphael cartoons, attended C.R. Leslie's lectures at the Royal Academy Schools and visited the Royal Academy exhibition where he would have seen the first public exhibition of paintings by the Pre-Raphaelite Brotherhood, as well as his own portrait by William Boxall.[3]

The styles and values in art which Whistler first enthusiastically embraced, and afterwards rejected, were never entirely forgotten. By the time of 'The Red Rag' he regarded a title from Dickens as 'a vulgar and meretricious trick', but as a student at West Point in the early 1850s he was a regular illustrator of subjects after Dickens (fig.15) as well as Walter Scott, and an avid reader of their novels. Already familiar with modern British art and its traditions, he knew that genre and narrative painting after subjects by these popular authors was exactly what would be required of him if he were ever to exhibit at the Royal Academy. At West Point he was not only familiar with Dickens's illustrators, Cruikshank and Hablot Browne, but also with the work of Gavarni and Bertall, which prepared him for the Realist art he encountered in Paris. Under the drawing instructor at West Point, Robert Weir, who had worked in Rome but whose sympathies were with Dutch art and the naturalist tradition, Whistler illustrated the popular authors of the day and recorded the student life around him. The very literal watercolour copies he made shortly before he left for Europe, after colour engravings of paintings by Delaroche and Turner (fig.16), were clearly made in anticipation of the art he believed would be expected of him in Paris and London.

While he was back in the United States his half-sister's marriage brought his family ever closer to Britain and Europe. The Bootts reaffirmed their connections with the Hadens by the marriage of Kirk Boott's niece, Mary Love Boott, to Francis Seymour Haden's brother, Charles Sydenham Haden, who was a merchant in Lyons. That these transatlantic alliances, all originating in Derby, played an important role in Whistler's return to Britain is confirmed by

his early group portrait *The Music Room* (fig.17), which he painted for his mother soon after he settled in London in 1860. It shows his niece Annie seated, the face of her mother Deborah (his half-sister) reflected in the mirror and, standing, Ethel Sophia Isabella Boott, the sister-in-law of Charles Haden. When Whistler saw it years later, after retitling it *Harmony in Green and Rose*, he thought it superior to anything a Dutch artist could have painted. Its rather self-conscious compositional complexity and careful finish reflect the Dutch naturalist tradition, on which much British painting at the time was based.

Whistler went to Paris to train for a career as a 'British' artist, as did Thomas Armstrong, George Du Maurier, Frederic Leighton and Edward Poynter, who were all there at the same time; for a time he shared accommodation with some of them. Except for one or two paintings of peasants, influenced by Courbet, whom he met only towards the end of his stay, much of what Whistler did in Paris between 1855 and 1859 was intended for sale in Britain and the United States, to friends and family who supported him, or made in

15 *Sam Weller's Landlord in the Fleet (The Cobbler)* c.1850
Pencil and watercolour on paper
10.4 × 14.9 (4 × 5⅞)
Freer Gallery of Art, Smithsonian Institution, Washington, DC; Gift of Charles Lang Freer

16 *Copy after Turner's 'Rockets and Blue Lights (close at hand) to warn steamboats of shoal water'* 1855
Watercolour on white paper laid down on card
51.1 × 72.7 (20⅛ × 28⅝)
Private Collection

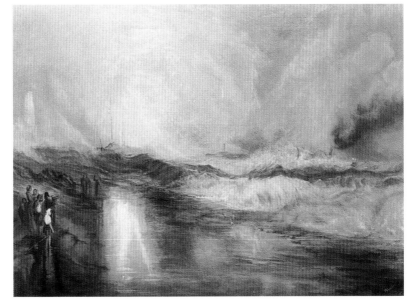

preparation for a career in London. Although he enrolled in Charles Gleyre's atelier, copied a work by Ingres and some modern paintings in the Luxembourg, a lot of the work he did in Paris was no more French than the work he had previously done could be called American. His etchings *Douze eaux-fortes d'après nature* (fig.18), popularly known as 'The French Set', were dedicated to Haden, who would have drummed into him Ruskin's advice to the young artist in the first volume of *Modern Painters* (1845), conceived in Turner's defence, to 'go to Nature in all singleness of heart ... rejecting nothing, selecting nothing, and scorning nothing'. Whistler made the etchings from drawings and watercolours he had produced on a journey along the Rhine with a fellow artist. The drawings, some of them very sketchy, are certainly 'after nature'. There are groups of figures in cafés, street scenes and the

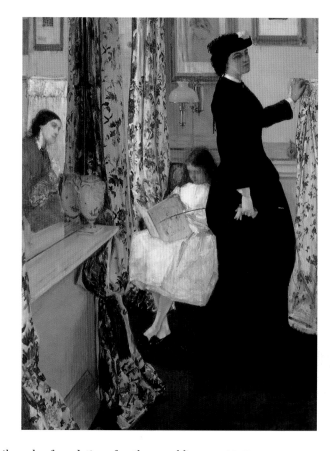

17 *Harmony in Green and Rose: The Music Room* 1860–1
Oil on canvas
96.3 × 71.7
(37⅜ × 28¼)
Freer Gallery of Art, Smithsonian Institution, Washington, DC; Gift of Charles Lang Freer

Rhine itself. Although he was penniless, he found time for the gambling saloon in Baden-Baden. His drawing of gamblers bent over the tables is one of his more elaborate, but it was never made into an etching; he was already thinking about London and a painting for the Academy. The hard graft came on returning to Paris when the drawings had to be made into etchings, a technique he had learned in the United States Coast and Geodetic Survey in Washington, DC, where for a few months before he left for Europe he had etched maps and drawn topographical plans. Some of the etchings in 'The French Set', of figures working in interiors, are based on similar compositions by Dutch artists such as Pieter de Hooch; the rustic character of other scenes owes much to Barbizon subjects and etchers like Charles Jacque.[4]

'The French Set' was Whistler's introduction to modern French art and Gustave Courbet. He also met Fantin-Latour and Legros who shared his interest in Realist subjects. Both Fantin-Latour and Whistler planned modern interiors to submit to the Salon of 1859. Fantin-Latour's *Two Sisters* was accepted, but Whistler's *At the Piano*, which like *The Music Room* included portraits of Deborah and Annie Haden, was rejected. It was exhibited at the Royal Academy the following year where it enjoyed a modest success and was bought by the Academician John Phillip. Whistler needed to find another modern subject for both the Salon and the Academy. He travelled in search of one, first to Brittany in 1861. The marine he painted there, *Alone with the Tide*, with a little

18 Title page to *Douze eauz-fortes d'après nature* ('The French Set') 1858 Etching; black ink on chine collé 11.1 × 14.6 (4⅜ × 5¾) Hunterian Art Gallery, University of Glasgow

Breton girl dozing on the beach, was an attempt to rival the popular Victorian marine painter James Clarke Hook. In the autumn of 1862 he stayed for several months on the south-west Atlantic coast of France near the border with Spain. He wanted to be the first of his friends to visit Madrid to see the paintings of Velázquez, which were much talked about in Paris. Near Biarritz he met another rival, Gustave Colin, who specialised in genre subjects of Basque life. There Whistler planned an elaborate sea coast scene with a ship in danger of breaking up on the rocks; on the shore was a Spanish sailor in red, and some fishermen and women, light against a dark sea. His description of it, in a letter to Fantin-Latour, makes it sound like a Turner; but the broadly painted breakers in *Blue and Silver: Blue Wave, Biarritz* (fig.19), the only seascape he brought back, look more like Courbet than Turner; he described painting them outdoors, 'as solid as if cut from stone'.

In London in the 1860s the kind of art of which he was later so critical made the most lasting impression on him. At first he was 'received graciously by the painters', he told his biographers.

> Then there was coldness and I could not understand. Artists locked themselves up in their studios – opened their doors only on the chain; if they met each other in the street they barely spoke. Models went around silent, with an air of mystery. When I asked one where she had been posing, she said, 'To Frith and Watts and Tadema'. 'Golly! What a crew!' I said. 'And that's what they says when I told 'em I was a'posing to you!' Then I found out the mystery: it was that moment of painting the Royal Academy picture. Each man was afraid his subject might be stolen. It was the great era of the subject.[5]

Whistler tried everything when he first worked in London. In addition to sea and river scenes, including his Thames etchings, he also represented the old being replaced by the new, with a painting of the scaffolding being removed from the recently completed Westminster Bridge. But he still needed the sort of figure subject which his fellow artists so jealously guarded, and which fed the public appetite for narrative drive and human drama in painting. If his painting was to be exhibited in Paris it also had to look like a British picture –

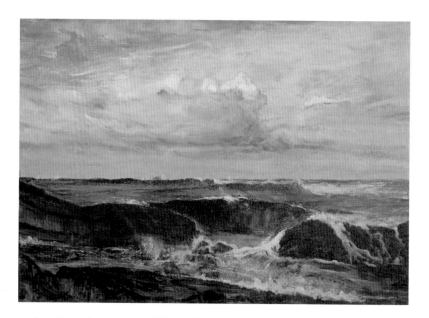

19 *Blue and Silver:*
The Blue Wave,
Biarritz 1862
Oil on canvas
65.4 × 88.9
(25¾ × 35)
Alfred Atmore Pope
Collection, Hill-Stead
Museum,
Farmington, CT

and perhaps also represent life in a big city, as Baudelaire had advocated in his Salon review of 1859. A subject emerged to meet these dual requirements from Whistler's observation of Thames life while he was making his etchings.

Wapping (fig.20) was first conceived in 1860 as an elaborate narrative of sexual exchange, of a prostitute and her pimp setting up an innocent sailor, to entrap or defraud him. He explained in a letter to Fantin-Latour that in its original form the girl's dress was cut revealingly low, and she was telling the sailor not to expect any favours; the Thames background, he said, though difficult to achieve, had all been painted on the spot. He intended to submit it to the Salon and warned Fantin-Latour not to say anything about it to Courbet. It was the kind of incident Whistler might have seen enacted in the low-life dives off Ratcliff Highway, or read about in social commentaries by writers like Henry Mayhew; perhaps even an element of Dickensian humour was intended. For Victorian viewers it would have been an insalubrious variation on the subject of the fallen woman in art, but without any of the redemptive symbolism of William Holman Hunt's *Awakening Conscience*. *Wapping* was not exhibited until 1864, and in London not Paris, but by then Whistler had revised and repainted it so many times that the original narrative was no longer discernible. Although critics admired the vigorous realism of the background, the relationship of the figures made its meaning unclear.

These paintings show Whistler trying his hand at different sorts of British painting, but his ambition was to paint something that would be admired for its own sake rather than for its subject. *The White Girl* (fig.22) was conceived in Paris in 1861 with this in mind. The Royal Academy rejected it in 1862, and it was shown instead in a dealer's mixed exhibition which advertised it on the streets of London with sandwich boards as 'The Woman in White'. The reason for this was that Wilkie Collins's novel *The Woman in White* (1860) had been a runaway best-seller, and the management hoped that associating the picture with the book would bring in the crowds. This proves the point

Whistler later made in 'The Red Rag', that the right title can sell a picture, for in 1862 he was an unknown artist. When a critic in the *Athenaeum* wrote that *The Woman in White* (as it was now known) did not resemble the heroine of the novel, Whistler wrote a letter to the newspaper disowning the new title and stating that he had never read the book: 'My painting simply represents a girl dressed in white standing in front of a white curtain.' His refusal to accept the illustrative convention of painting was in contrast to that of an artist like Frith, whose *Railway Station*, a sweeping panorama of bustling modern life in which every incident tells a story, was on exhibition in London at the same time as *The White Girl*.

The subject of *The White Girl* prompted questions then as it does now. She holds a flower in her hand and stands on an animal-skin rug, on which flowers are also strewn. These details, together with the dominant whiteness, are an oblique reference to Holman Hunt's fallen woman and Millais's bridal subjects, which include flower symbolism. With Millais it is more a parodic echo than an influence, and when Millais saw *The White Girl* he immediately recognised that Whistler's inspiration had been Velázquez. When *The White Girl* was shown at the Salon des Refusés in 1863, the identity of the girl, her marital and emotional state, and the symbolism of the flowers all provoked intense speculation. Realist writers thought that she was a bride; some critics that she was a spirit or medium in a trance, and deliberately conceived in opposition to Realism; others that the painting was by a Pre-Raphaelite artist.

All these interpretations were beside the point. Whistler had hoped from the start that *The White Girl* would defy a conventional response. By deliberately making its symbolism inexplicit and insisting on a non-committal title (the 'Symphony' part of the title came much later) he wanted to distract the attention of critics away from what a picture represented to how it was painted, from it as a subject in nature, to it as an object in art. By entitling it *The White Girl* he was describing precisely what was being represented – just

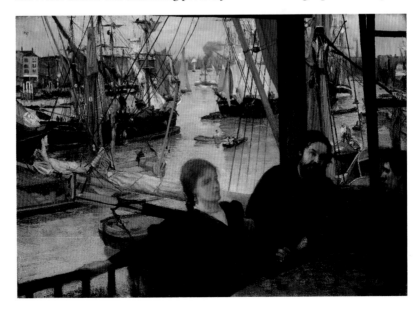

20 *Wapping* 1860–4
Oil on canvas
72 × 101.8
(28⅜ × 40¹/₁₆)
National Gallery of
Art, Washington,
DC, John Hay
Whitney Collection

as *The Twenty-fifth of December, 1860, on the Thames* (which was accepted by the Academy in 1862 and even more broadly painted than *The White Girl*) showed what it felt like to be on the river on that day. It was the realist truthfulness of his painting which his friends admired. His painting delivered what his titles promised, unlike Millais's *Parable of the Woman Seeking for a Piece of Money*, also exhibited in 1862, which even the conventional *Art Journal* found 'simply absurd, the figure being a modern maid-servant, with a broom in one hand, and a brass candle-stick in the other, looking for something on the ground'. *The White Girl* was the first full-length portrait of Whistler's to stand within the frame. By using the same tonal range for foreground and background for a figure picture Whistler evoked Velázquez, the artist he most wanted to emulate, and Manet, whose modernisation of spanish subjects rivalled his own.[6]

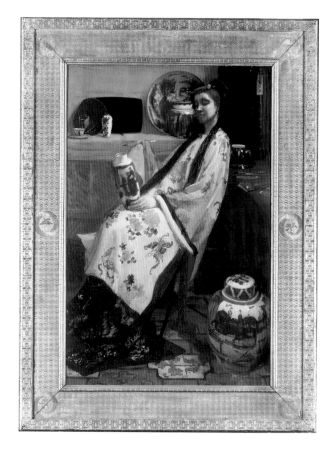

21 *Purple and Rose: The Lange Leizen – of the Six Marks* 1864
Oil on canvas
93.3 × 61.3
(36¾ × 24⅛)
The John G. Johnson Collection,
Philadelphia Museum of Art, 1917

Shortly after the exhibition of *The White Girl* in Paris Whistler began his 'Chinese-Japanese' pictures (in 1863 distinctions between the two cultures were not readily made). The subject matter of these paintings was probably encouraged by the interest of the dealer Ernest Gambart, who was always on the lookout for exotica (he signed up Lawrence Alma-Tadema at this time) and who had been introduced to Whistler by Rossetti. The first painting, which Gambart bought for 100 guineas (without the frame), was exhibited at the Royal Academy in 1864 as *Die Lange Leizen – of the Six Marks* (fig.21). This time Whistler used an enigmatic title to attract the viewer's attention. A visitor to the Academy who also shopped for the decorative arts in Regent Street would have known that 'Lange Liijzen' was Dutch for the 'long lady' decorations on Delft-imported blue and white Chinese porcelain. In the picture a very un-Asian-looking girl is shown signing the porcelain with the six potter's marks, surrounded by examples of it owned by Whistler, and other items including what may be a book of Japanese prints and a fan. The frame is the first that Whistler designed; for which he may have had help from Rossetti. There are spiral patterns, probably from Japanese sources, and at the corners and in the centre of each of the long sides, roundels bearing Chinese symbols for the 'six marks'. Whistler painted *The Lange Leizen* very slowly, according to his mother, taking things out and putting them back over a long period. A high degree

Opposite
22 *Symphony in White No. 1: The White Girl* 1862
Oil on canvas
213 × 107.9
(83⅞ × 42½)
National Gallery of Art, Washington, DC, Harris Whittemore Collection

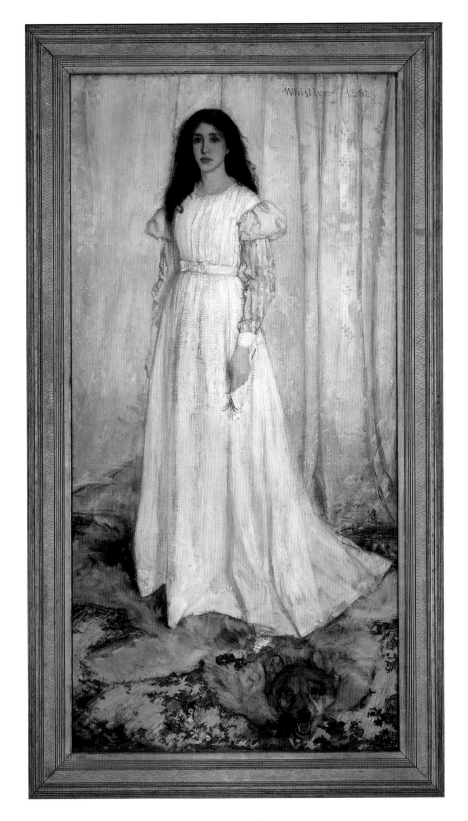

of finish was essential for Gambart, who would have wanted to publish an engraving – had the critical reception been more enthusiastic when it was exhibited at the Royal Academy in 1864.[7]

In her description of Whistler's progress on *Purple and Rose: The Lange Leizen – of the Six Marks* (the title Whistler gave it in 1892) his mother mentions that 'the several pieces of china & a pretty fan are arranged as if for purchasers'. Chinese blue and white porcelain, and subsequently Japanese art, became very fashionable after Whistler began to collect it in the early 1860s. Like Rossetti and Morris, he was aware that such objects were superior to many things of European manufacture, and that this was not irreconcilable with the fact that they could also be profitable. This is what he represents in *The Lange Leizen – of the Six Marks* and *Caprice in Purple and Gold: The Golden Screen*, which was exhibited at the Academy the following year. In their absorbed contemplation of the Chinese porcelain they decorate and the Japanese prints they hold, the women in Whistler's pictures are metaphors for commerce as well as representative of his ambition for a new kind of decorative painting. Within only a few years the best blue and white china had accrued considerable market value, as imitations were mass-produced for the Western market, offering opportunities for creative trading. By the mid-1870s a good blue and white pot had a market value comparable with that of one of his nocturnes. Dealers like Murray Marks, who specialised in the decorative arts and Chinese porcelain, and collectors of it like Sir Henry Thompson, whose 1878 sale catalogue Whistler illustrated, traded such items alongside Whistler's paintings.

The White Girl, exhibited like Manet's *Déjeuner sur l'herbe* at the Salon des Refusés in 1863, earned Whistler a prominent place, opposite Manet, in Fantin-Latour's group portrait *Hommage à Delacroix* (fig.23; Whistler is fifth from the left) at the Salon of 1864. As well as the French artists Félix Bracquemond, Fantin-Latour and Legros, there are also portraits of Baudelaire and the realist writers and critics Champfleury and Duranty. In the following year Whistler appeared even more prominently in Paris. Wearing the same kimono as his full-length subject in *La Princesse du pays de la porcelaine* (see fig.9), which he exhibited at the Salon as a follow-up to *The White Girl*, he appeared again with Manet and others in *The Toast: Homage to Truth*, the group portrait which Fantin-Latour afterwards destroyed. In spite of these credentials Whistler only exhibited in Paris once more, in 1867, the year of the Exposition Universelle, before concentrating all his energies on a career in London. With the exception of a small exhibition, at Durand-Ruel's in 1873, he did not return to Paris as a regular exhibitor until 1882.[8]

Whistler had wanted Rossetti to be in both of Fantin-Latour's group portraits, but Rossetti's failure to be in Paris at the right time for the sittings prevented him from appearing in them. Revered in Paris as *the* Pre-Raphaelite, Rossetti was a major reason Whistler pursued a career as a British artist rather than a French one. In contrast to Millais and other British artists mentioned here, whose painting Whistler emulated because he coveted their subjects or their success, Rossetti was the first major artist after Courbet whom he genuinely admired and wanted to be influenced by. Significantly for Whistler, Rossetti was never afraid to criticise Ruskin. For his part Rossetti admired the

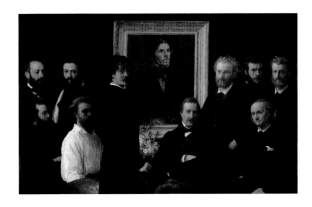

23 Henri
Fantin-Latour
Hommage à Delacroix
1864
Oil on canvas
160 × 250
(63 × 98⅜)
Musée d'Orsay, Paris

work of Legros, was indifferent to Fantin-Latour's, and hated that of Courbet and Manet. He preferred Jean-Léon Gérome, and lauded Delacroix. Such eclectic and original taste appealed to Whistler, who could learn from Rossetti without feeling artistically threatened by him. 'Not an artist, but a gentleman,' he used to say of him. Rossetti was independent, virtually self-taught and never exhibited, but had prodigious contacts which he generously shared with his friends. He helped Whistler sell his work (to Leathart of Newcastle, and Graham of Glasgow) and introduced him to Leyland of Liverpool, who bought *La Princesse du pays de la porcelaine*, and commissioned decorative paintings and then portraits of himself and his family.[9]

Within a year of meeting him Whistler had adopted Rossetti's style for his portrait images of Johanna Hiffernan, his Irish mistress and muse, and the claustrophobic space and luminous colour of Rossetti's medieval subjects for his 'Japanese' pictures. Rossetti had another attraction. He shared a house with Britain's most learned modern poet, Algernon Charles Swinburne. In his lifetime Swinburne had the paradoxical distinction not only of being the first defender of Baudelaire in English, but also of being tipped to succeed Tennyson as Poet Laureate. As Manet's literary amanuensis in Paris was Baudelaire, Whistler could not possibly have had a better friend in London than Swinburne. Swinburne shared Baudelaire's belief in the universality of artistic expression and argued that painting could complement literature without having to illustrate it. He gave Whistler the authority to distinguish between modernity in art, and art, like Frith's, which only illustrated modern subjects. By the time of the Salon des Refusés, when he met Baudelaire, who praised *The White Girl*, Whistler realised that there was more to art than Realism. Some critics had already sensed *The White Girl* was about something else. One of them, Théophile Thoré, writing under the pseudonym Willelm Bürger, presciently demonstrated the direction Whistler's art was about to take. For Thoré *The White Girl* was a 'phantom' no one could possibly see for themselves: it was a 'rare image, conceived and painted like a vision that would appear in a dream, not to everybody, but to a poet. What's the good of art if it doesn't show things you can't see? – *All right!*'[10]

3

MODERNITY

And Paris produces – Vienna furnishes – and Birmingham and
Manchester arose in their might – and there are Swiss chalets in
Brighton – and why not?

(Whistler, from a draft of the 'Ten O'Clock'
lecture in Glasgow University Library, 1885)

In 1859, the year Whistler settled in London, Baudelaire wrote in his Salon
review about photography, of which he strongly disapproved: 'Poetry and
progress are like two ambitious men who hate one another with an intense
hatred, and when they meet on the same road, one of them has to give way.'
Although Whistler occasionally made use of photography, he came to share
Baudelaire's reservations. 'The imitator is a poor kind of creature,' he wrote
in 'The Red Rag'. 'If the man who paints only the tree, or flower, or other sur-
face he sees before him were an artist, the king of artists would be the photog-
rapher.' In his Salon review of 1859 Baudelaire extended his argument about
the paradox between poetry and progress by airing a popular prejudice which
he hoped his readers would appreciate: 'What man, worthy of the name of
artist, and what true connoisseur, has ever confused art with industry?' The
popular belief that art was irreconcilable with industry did not preclude
Whistler from representing it in his Thames etchings and paintings (fig.24).
Hundreds of ant-like figures scurry across the wharves and jetties in the etch-
ings, and work by the riverside in his paintings. When Baudelaire wrote about
the Thames etchings in 1862 he praised them, not because they were an accu-
rate record of industry, but because they represented the 'profound and intri-
cate poetry of a vast capital'. For Baudelaire their poetry transcended their
content.[1]

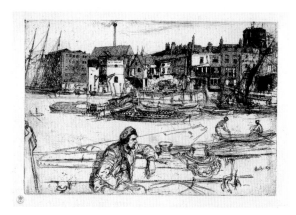

24 *Black Lion Wharf*
1859
Etching and drypoint
printed in black ink
on cream laid paper
15 × 22.5 (5⅞ × 8⅞)
The Victoria and
Albert Museum,
London

Invisible in the etchings, but only a quarter of a mile away, lay the commerce of the City which had attracted Whistler to London to make a living. To the City came engineers and businessmen to finance their industry, like the engineer Alfred Chapman from Liverpool, and the wallpaper magnate John Gerald Potter from Preston, whose Lancashire families Whistler had known even before he returned to Europe from the United States; and men of commerce – bankers and insurance brokers like Alexander Constantine Ionides, merchants like John George Cavafy, who bought the art of the Pre-Raphaelites and would shortly invest in Whistler's work by commissioning portraits and paintings of river life. For them, as for Whistler, modern art was synonomous with modernity, not least because it was an investable commodity which would eventually show a profit like everything else.

Before looking at the modernity of Whistler's art, it is useful to consider some of the things he did in Paris before he arrived in London. A comparison of the two etchings *Fumette* (fig.25) and *Finette* (fig.26) alerts us to two kinds of modern subjects. Whistler shows us very different types of Parisian women of the 1850s. 'Fumette' is a *grisette*, a seamstress whose grey clothes mark out both her occupation and her expectations, with political implications which would have interested Courbet. Her prematurely aged posture bent submissively indicates her profession as much as the subtly graded shades of black and white used to describe her. This is a woman born to serve, whose social prospects are limited by association with *calicots* or *étudiants*. Both drapers' assistants and students were traditionally independent and fearsome rivals. While keeping themselves apart, *étudiants* competed for attention not only

Below left
25 *Fumette* 1858
Etching; dark brown ink on cream laid paper trimmed to platemark
16.6 × 11
(6½ × 4¼)
Hunterian Art Gallery, University of Glasgow

Below right
26 *Finette* 1859
Drypoint; black ink on white paper
29.1 × 20.1
(11⅜ × 7⅞)
Hunterian Art Gallery, University of Glasgow

with *calicots*, but for the favours of a new type of woman, who danced to entertain the crowds that flocked to the bal Bullier. Here 'Finette' was a celebrated exponent. Whistler's 'Finette' wears an elegant dress and proudly occupies a commanding position in her fashionable new apartment high above the city, with paintings on the walls, and the bibelots of nighttime masquerade – jewellery box, mask and feathers – casually strewn aside. Unlike 'Fumette', this is a woman with a future as well as a past. A few years after Whistler came to London 'Finette' also crossed the Channel to entertain London audiences with an early version of the cancan.[2]

It is not *Finette* alone which constitutes the new kind of 'modernity' in Whistler's art. To understand his modernity we must relate the etchings to a painting he made at this time, which also has a modern subject but is as different again as *Finette* is from *Fumette*. On entering the bal Bullier for the latest

27 *La Mère Gérard*
1858–9
Oil on canvas
30.5 × 22.5
(12 × 8⅞)
Present whereabouts
unknown

in entertainment and dancing the visitor was reminded of the price to be paid for living in the new centre of Paris, where the poorest members of the community had been displaced by Baron Haussmann's boulevards and apartments. Selling flowers at the entrance door to the dance hall was a very old woman who was known to customers as 'La Mère Gérard' (fig.27). She had once run a small lending library, was said to write verses, but was now nearly blind. The very antithesis of 'Finette' in all her finery, a casualty of Napoléon III's modernisation of Paris, she is shown by Whistler in her rags as Rembrandt depicted old women in the Jewish quarter of Amsterdam. Whistler knew something else about the old crone. She had a tapeworm, and when he asked her what she would like to eat or drink, would reply 'Milk; he likes that!' Such a condition could not be depicted by a painter. But an explicit connection between putrefaction, modern life and the parasitic reliance of the living on the dead, was the province of Baudelaire, who was prosecuted for his volume of verse *Les Fleurs du mal*, which was banned in 1857. By choosing two contrasting modern subjects observed from life at the bal Bullier, Whistler was alluding to one of Baudelaire's most explicit poems, 'Une Charogne', in which the poet contemplates his beautiful mistress transformed into a rotting maggot-eaten carcass. For both Baudelaire in *Les Fleurs du mal* and Whistler, modernity in their work meant more than objectifying modern reality. It had to represent sensations not previously experienced in the city – in Paris and London – where competing interests and conflicting values were constantly being fought out between the old and the new.

In 1862 Swinburne had written the first review of *Les Fleurs du mal* in English. He regarded Baudelaire as his 'brother'. It is fitting that when Whistler met Swinburne shortly afterwards he gave the portrait of *La Mère Gérard* to his new friend. Whistler's *The Little White Girl* (fig.28), exhibited at the Royal Academy in 1865, shows a young woman, much as Rossetti might have painted her, introspectively gazing at herself in a mirror. On the frame were printed Swinburne's verses 'Before the Mirror', which suggest that continual change is natural to all things, including beauty, but which, like William Blake's rose, will inevitably become diseased and die. Swinburne wrote the poem after seeing Whistler's picture, as if to illustrate what Baudelaire wrote in his Salon review of 1846, that 'the best account of a painting can be a sonnet or an elegy'.[3]

It was not just Swinburne's poetry, but his ideas about what poetry should and should not do, that made Whistler ask radical questions about modern painting. The conventional idea that poetry, or painting, was the vehicle for a moral lesson, what Baudelaire called the 'heresy of didacticism', a conceit he inherited from Edgar Allan Poe, was totally unacceptable to both Swinburne and Whistler. Countless volumes of bad sentimental verse were published, and scores of pictures illustrating trivial moral stories exhibited, every year. They believed that the only morality proper to painting should be the aesthetic morality integral to its form and colour. Adopting the slogan 'art for art's sake', Swinburne displaced the value of art from subject to treatment and established the basic principle of modernism. Swinburne's theory, which he developed over several years for his study *William Blake* (1868), might have been relatively uncontroversial had it not been for the publication two years

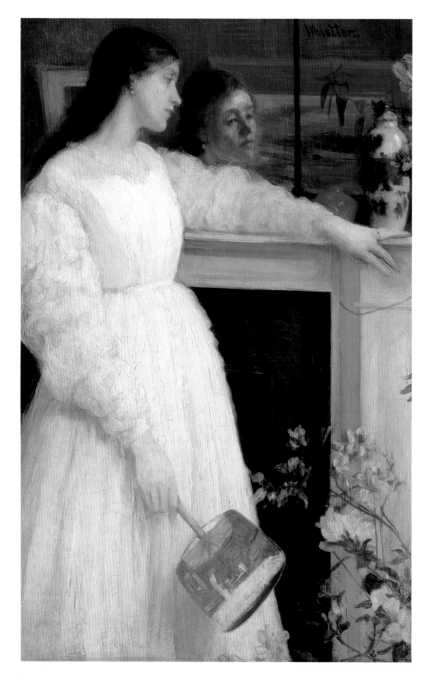

28 *Symphony in White, No. 2: The Little White Girl* 1864
Oil on canvas
76.5 × 51.5
(30⅛ × 20¼)
Tate

earlier of his *Poems and Ballads*, which caused a sensation. His verse combined religious and pagan images with narratives of lesbian and sadomasochistic pleasure. Like Baudelaire, who poeticised the duality of 'pain and pleasure', Swinburne's 'blasphemy' was that love had been experienced more intensely and passionately before the advent of the restrictive and oppressive morality of Christianity.

In 1863 Baudelaire sent a copy of his essay 'Richard Wagner et Tannhäuser

à Paris' to Swinburne, in which he suggested that it would be surprising 'if sound could not suggest colour, or that colours could not give the idea of melody, and that sound and colour were not suitable media for translating ideas'. The theory of synaesthesia was central to Swinburne's writing technique, as it was to Edgar Allan Poe, whose essays 'The Philosophy of Composition' (1846) and 'The Poetic Principle' (1850) exercised a powerful influence on Whistler's formalist theory of art. In the poetry of both Poe and Swinburne sounds and colours are deployed impressionistically to give substance and shade to its meaning. The strong harmony of yellow and blue in Whistler's sketch for *Annabel Lee* (fig.29) is a visual counterpart to the insistent rhythm of Poe's poem of the same name. It is only one of three works to which Whistler ever gave a literary title, which indicates the extent of his admiration for Poe and the debt he owed him. He never failed to remind his American visitors that Poe, like himself, was an alumnus of West Point.[4]

In the second chapter of *William Blake* Swinburne wrote that 'the result of having good art about you and living in a time of noble writing or painting', was that the 'spirit and mind of men' should receive 'a certain exaltation and insight caught from the influence of such forms and colours of verse or painting ... art for art's sake first of all, and afterwards we may suppose all the rest shall be added to her'. Such sentiments accord with Ruskin's, and for a while Ruskin was an admirer of Swinburne. He was attracted by his technical facility and the sensuality of his verse, until he began to feel uneasy with the

29 Sketch for
Annabel Lee
*c.*1869–70
Oil on wood
30.7 × 22.6
(12 × 8⅞)
Hunterian Art
Gallery, University of
Glasgow

pleasure he experienced from the frank expression of such pagan sentiments. For Ruskin, synaesthesia was never a sufficient end in itself for art, although he made liberal use of it as a technical device in his writing. However, music was a different matter, which for him possessed something of the mysterious 'other' he was always on the lookout for in great art. In Book V of *Modern Painters* (1860) he uses musical metaphors as Swinburne does in the second chapter of *William Blake*. In a picture Ruskin distinguishes between 'the merely pleasant placing of lines and masses', which he calls 'the emotional results of such arrangements', which can be explained, and 'the perfection of formative arrangements', which 'cannot be explained, any more than that of melody in music'. In analysing 'the observing and combining intellect' of Turner's compositions, he demonstrates that 'a great composition always has a leading emotional purpose, technically called its motive, to which all lines and forms have some relation. Undulating lines, for instance, are expressive of action; and would be false in effect if the motive of the picture was one of repose. Horizontal and angular lines are expressive of rest and strength.'

On Sunday 13 August 1865 Swinburne arranged to bring Ruskin and Burne-Jones round to Whistler's studio to see his recent work. On his easel was an unfinished picture of two girls dressed in white on a sofa (fig. 30). Although we do not know for certain whether Ruskin kept his appointment, Whistler wrote to Fantin-Latour three days later to say that he had made 'enormous progress' with the picture. 'Most of all it's the composition which occupies me,' he wrote, and below a drawing of it described the lines and formal emphases of the composition: 'what do you think of the line at the top isn't it good? and the arrangement of the two arms on the sofa, like that' (and he drew two diverging lines to indicate the emphasis). In 1867 he exhibited the painting at the Royal Academy as *Symphony in White, No. 3*, thus retrospectively titling *The White Girl* and the *Little White Girl* as *Symphony in White, No. 1* and *Symphony in White, No. 2* (figs. 22 and 28).

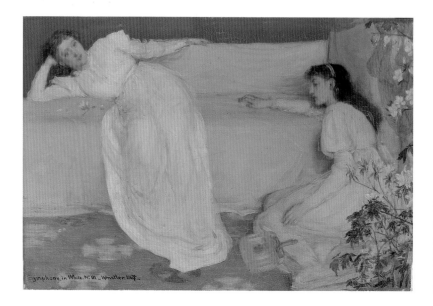

30 *Symphony in White, No. 3* 1865–7 Oil on canvas 51.4 × 76.9 (20¼ × 30¼) Barber Institute of Fine Arts, University of Birmingham

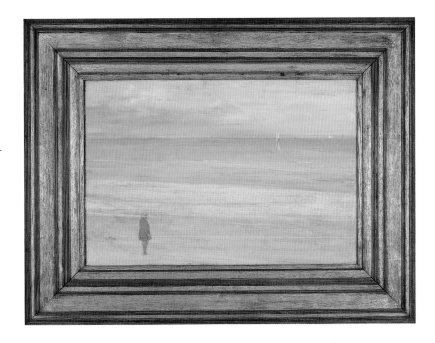

By the summer of 1865 Whistler had all but discounted the relevance of Courbet for his art. He planned a six-foot tall picture of his studio interior, with his collection of Chinese porcelain and two female figures, one Western and the other Japanese, a reprise of *The White Girl* and *La Princesse du pays de la porcelaine*. In it he also intended to include portraits of Fantin-Latour and Albert Moore, whom he had just met and whose work he very much admired. He wrote of the three of them 'continuing the tradition of 19th century painting'. Had Whistler completed such a picture (of which only oil studies survive) and sent it to the Salon as planned, it would doubtless have been interpreted in Paris as a direct challenge to Courbet, who was no longer as influential as he had been in the 1850s. When Whistler met Courbet in Trouville a few months later he included him in the foreground of one of his seascapes (fig.31). Courbet had painted a similar subject ten years earlier, but instead of showing him commanding the sea with an imperious gesture (as Courbet represented himself), Whistler depicted him absorbed by nature, in a near-abstract swirl of sea, sky and sand. *Harmony in Blue and Silver: Trouville*, which is very different from the seascapes Whistler painted in France in 1861 and 1862, suggests the lines from Baudelaire's 'L'Homme et la mer': 'Man, for as long as you are free you will cherish the sea! / The sea is your mirror ... It gives you pleasure to immerse yourself in your own image / You embrace it with arms and eyes ...'.

In 1865 the aestheticism of Rossetti and Swinburne suggested to Whistler several routes his art might take. One was the sensuality of Swinburne's subjects, to which he was strongly drawn, but which he lacked the technical ability to communicate in paint. Another centred on Japanese art, which treated modern subjects decoratively, and like the great art of the past possessed the vitality contemporary western art seemed to lack. Unwilling to abandon

39

modern subjects, Whistler spent several years examining the implication of Japanese art for European painting. The variations on the subject of the balcony, in watercolour and oil, made between 1864 and 1870, are based on a Japanese print, and combine different degrees of realism with decoration (fig.32). A third way was to return to first principles, suggested to him by Albert Moore, the source of whose art was Classical sculpture, and whose working procedure entailed squaring up full-scale cartoons to transfer to canvas. For the rest of the decade Whistler made many chalk and pastel drawings of clothed and nude models, standing and seated, to improve his draughtsmanship and facilitate his working methods. Shortly after Baudelaire's death in August 1867 he wrote a long letter to Fantin-Latour in which he said how much he regretted the appeal of Courbet's Realism, and wished he had been a pupil of Ingres, who had died earlier in the same year.[5]

The 'Six Projects', commissioned by Leyland in 1867, put to the test the two

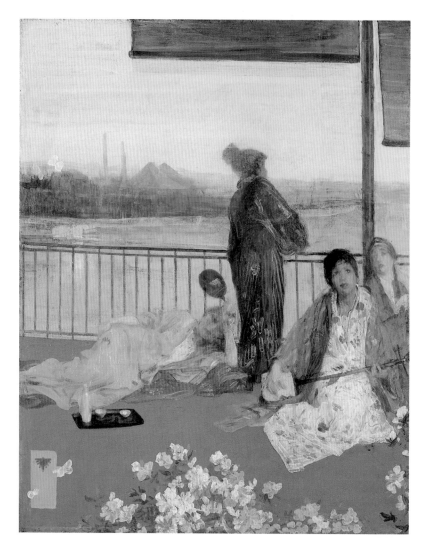

32 *Variations in Flesh Colour and Green: The Balcony* 1864–70 Oil on wood panel 61.4 × 48.8 (24⅛ × 19⅛) Freer Gallery of Art, Smithsonian Institution, Washington, DC; Gift of Charles Lang Freer

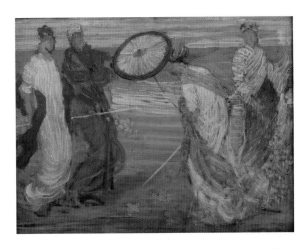

33 *Symphony in Blue and Pink* (from the 'Six Projects') *c.*1868 Oil on millboard mounted on wood panel 46.7 × 61.8 (18¾ × 24¼) Freer Gallery of Art, Smithsonian Institution, Washington, DC; Gift of Charles Lang Freer

years of 'education' to which Whistler had subjected his art since 1865. Their subjects are women and flowers in a garden or conservatory (see fig.10), and with parasols on a shore (fig.33); others show women embarking at a jetty and gazing across water; and in one a Venus rises from the sea. The figures combine Classical drapery with figures derived from the prints of Kiyonaga. The oil sketches may also relate to some of the mythopoeic themes in Swinburne's *Poems and Ballads.* In defending his verse in 1866, Swinburne had explained that after tempestuous passion and the recognition of death in the early poems had worked itself out, the last section of his book concerned the redemption of the soul, which was represented by the goddess Hesperia, the daughter of Venus. Hesperia was central to Swinburne's cyclical theory of creativity, of the Apollonian song of beauty surviving through the renewal of art, and transmitted by artists from the past to the present. The 'Six Projects' also represent such a renewal, for the drapery and forms combine the Classical art of the past, that of pre-Christian Greece, with the recently discovered art of pagan Japan. They are a union of opposites harmonised by drawing and colour, and symbolised for Whistler the ideal equilibrium between man and woman. The transmission of the art of the past to the present had an immediate meaning for Whistler and Swinburne, because of Baudelaire, who had died at about the time Whistler began work on the 'Six Projects'. In his elegy to Baudelaire, 'Ave atque Vale', Swinburne commemorates the sound of Baudelaire's 'sad soul': 'My spirit from communion of thy song – / These memories and these melodies that throng ... / These I salute, these touch, these clasp and fold / As though a hand were in my hand to hold.' From beyond the grave comes the communion of art to renew the art of the future. The communion of art and artists, between the past and present, is the central theme of Whistler's 'Ten O'Clock' lecture of 1885. In 1867 it was the legacy of Baudelaire, passed on to him by Swinburne. The 'Six Projects', like Swinburne's 'Ave atque Vale', is Whistler's memorial to Baudelaire.

The public controversy over *Poems and Ballads*, and Whistler's association with Swinburne, may have affected his career. Nor was it helped by his inability to gather sufficient support from fellow artists to be elected a member of the Academy. *Arrangement in Grey and Black: Portrait of the Painter's Mother*

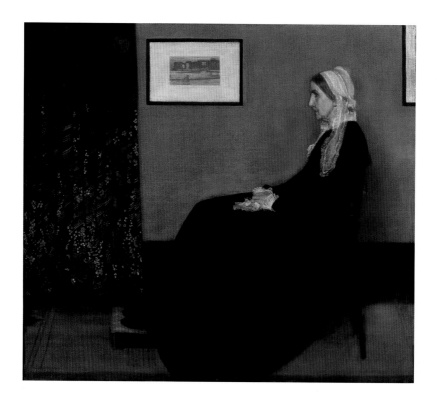

34 *Arrangement in Grey and Black No. 1: Portrait of the Painter's Mother* 1871
Oil on canvas
144.3 × 162.5
(56¾ × 64)
Musée d'Orsay, Paris

(fig. 34) was his last submission to the Academy in 1872. In a book of press cuttings kept by Whistler, one critic in 1872 complained that 'An artist who could deal with large masses so grandly might have shown a little less severity, and thrown in a few details of interest without offence.' Walter Sickert annotated the cutting with Whistler's suggestion that 'suitable details' might be 'a glass of sherry & the Bible!' However, Swinburne, in his otherwise damning review of the 'Ten O'Clock' lecture in 1888, praised the portrait for 'the intensity of pathetic power', which gave 'to that noble work something of the impressiveness proper to a tragic or elegaic poem'. For with an arrangement of no other colours could Whistler have expressed, for Swinburne, 'the intense pathos of significance' of his mother, who when Whistler painted her portrait was approaching the twilight of her years.[6]

While working on the portrait of his mother in 1871 Whistler had painted the Thames at night, which painting he first called a 'moonlight'. As with *The White Girl* he was anxious that the title should not detract from the painting, and thought even 'moonlight' might have been too specific, suggesting that concealment as much as revelation was already part of his artistic programme. In 1872 he renamed it a 'nocturne', a title proposed by Leyland, whom Whistler thanked: 'it is really so charming and does so poetically say all I want to say and *no more* than I wish' (fig. 35). The poetical influence may again have been Swinburne's, for in a poem very much in the style of Baudelaire, called 'Nocturne' (1871), he addresses night as the source of anguish as well as love through her capacity to change into day. The subject of the poem is the artist's search for permanence in the face of the cyclical change of nature,

a metaphor for the painter as well as the poet. It was the subject of a dinner table conversation which Alan Cole recorded in his diary for 6 January 1876:

> With my father and mother to dine at Whistler's. Mrs Montiori, Mrs Stansfield and Gee there. My father on the innate desire or ambition of some men to be creators, either physical or mental. Whistler considered art had reached a climax with Japanese and Velasquez. He had to admit natural instinct and influence – and the ceaseless changing in all things.[7]

There are few topographical clues to the nocturnes, and when they were first exhibited a viewer unfamiliar with London south of the river would not have recognised the locations. Only one of the nocturnes, the first Whistler painted, shows Chelsea from the south side; with the old church and houses clustered around it. Of the rest nearly all are of Battersea (fig.35) and take their viewpoint from the house Whistler leased in Lindsey Row upstream of the bridge. A church spire, a chimney, the lights reflected in the water are all that can be seen; everything else, including the filth emptied into the Thames from the chemical industry on the far shore, is absorbed by the darkness. In *Variations in Pink and Grey: Chelsea* fashionably dressed figures, with a hint of Japan, are seen near the Thames by day (fig.36). They are walking on what was to become the Chelsea Embankment, which opened in the summer of 1874. To build it the old riverside houses around the church had been torn down in

35 *Nocturne: Blue and Silver – Cremorne Lights* 1872
Oil on canvas
50.2 × 74.3
(19¾ × 29¼)
Tate
[Illustrated here in a standard nineteenth-century frame]

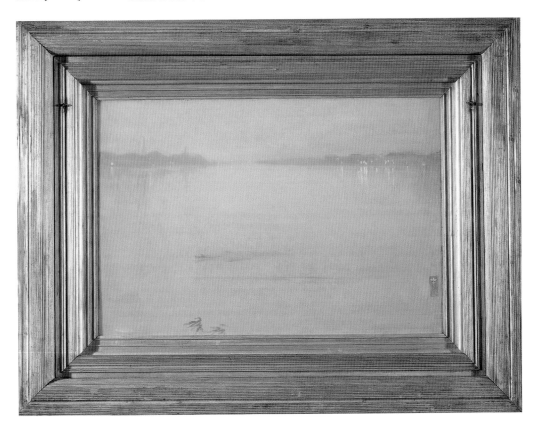

1872. When Whistler built a new house for himself in Tite Street in 1877–8 he moved downstream to benefit from the Embankment, which concealed a modern sewage disposal system, a facility he did not have in Lindsey Row. The *Building News* suggested that the Embankment could resemble the modernity of Paris, and be 'converted into a boulevard … lined with cafés, restaurants, little paradises and pavilions, with marble tables, coffee stalls, and pretty paraphenalia of the kind'.[8] It never happened because the building of the Embankment destroyed the riverside commerce and nothing ever replaced it. When Whistler returned to live in Chelsea in the 1880s it was the surviving old shop-fronts, dating from the pre-industrial age, that he sought out for his small oil panels and watercolours. He hardly ever drew a modern building.

In his address to the jury at the trial, Ruskin's Counsel said, 'I do not know whether the young ladies would look at the blue and gold nocturne representing Cremorne, and be able to say much about it, because it is a subject they do not understand, for of course, I hope, they have never been to Cremorne [laughter]. The other sex might have been and know something about it.' Whistler painted *Nocturne in Black and Gold: The Falling Rocket* (fig. 37), and five other subjects from Cremorne Gardens, probably in 1875. The fact that he made them just when the Embankment had opened, and two years before Cremorne Gardens closed, is not without significance. The Embankment stopped short of Battersea Bridge, leaving the gardens symbolically isolated a quarter of a mile from its modern amenities. Cremorne had been a place of public entertainment since 1846, the modern equivalent of Ranelagh in the previous century. It was devised to look like the country in the daytime, when nursemaids with their charges were welcome, but by night the lighting and artifice made it the perfect refuge of the weary worker from the city. Music, dancing, singing, supper, drink, speciality acts, theatre, fireworks and inevitably prostitution were all available.

One of Whistler's Cremorne paintings shows visitors relaxing with a drink between dances and watching the fireworks (fig. 38); in another an assignation is made on the lawn outside the supper boxes. It is difficult to get a sense of the noise and energy of Cremorne from Whistler's paintings. When asked at the trial whether any member of the public 'would go to Cremorne if he saw your picture? (Laughter)', Whistler had to admit that 'it wouldn't give the public a good idea of Cremorne'. By the early 1870s Cremorne's clientele was far noisier and more socially inclusive than it had been before. For residents nearby, concerned for the value of their property, the reality of Cremorne was incompatible with the expectations of modern life symbolised by the Embank-

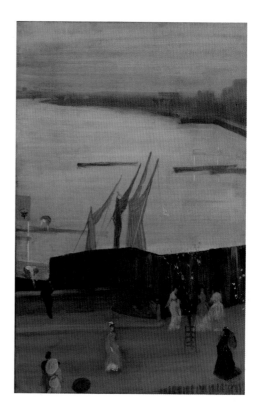

36 *Variations in Pink and Grey: Chelsea* 1871–2
Oil on canvas
62.7 × 40.5
(24⅝ × 16)
Freer Gallery of Art, Smithsonian Institution, Washington, DC; Gift of Charles Lang Freer

37 *Nocturne in Black and Gold: The Falling Rocket* c.1875
Oil on wood panel
60.3 × 46.4
(23 × 18)
The Detroit Institute of Arts. Gift of Dexter M. Ferry, Jr
[In 1878 Whistler described the original frame as 'traced with black' and signed with a butterfly]

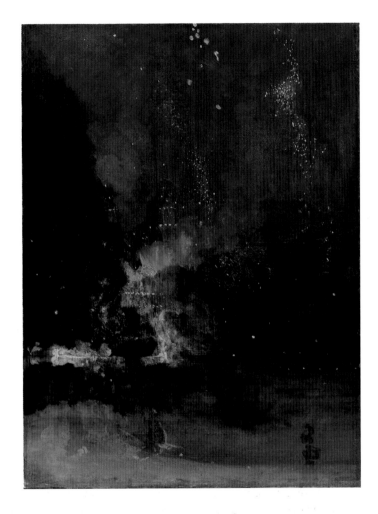

38 *Cremorne Gardens, No.2* c.1875
Oil on canvas
68.6 × 134.9
(27 × 53⅛)
The Metropolitan Museum of Art, John Stewart Kennedy Fund, 1912

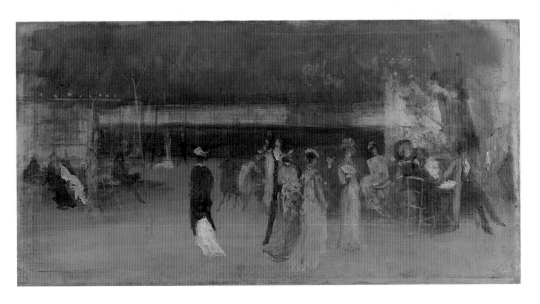

ment. Complaints about drunkenness and the number of brothels in the vicinity became more and more insistent. In 1876 the Chelsea Vestry granted Cremorne a licence for the last time. Cremorne did not close because it was immoral but because it could not profitably be kept open. In its place the wife of the leaseholder laid out a substantial speculative estate of artisan dwellings which is still there today. The unrestrained freedoms of Cremorne, on which Whistler's paintings do not dwell, represented a pre-modern era that lacked social mobility and resisted swift changes in fashion.[9]

In 1874, the year of the first Impressionist exhibition in Paris, Whistler leased a gallery in central London to provide him with an extended showcase to display all branches of his art, including portraits, oil sketches, drawings and etchings. He had the walls distempered in pastel shades, and arranged rugs, furniture and flowers to suggest how his work could be displayed by clients in their own homes. In this way he hoped to attract buyers who might otherwise go to William Morris, who by then had more than his share of the market and in 1876 had opened a shop in Oxford Street. The exhibition was arranged to demonstrate Whistler's skill as a decorative artist as well as a portraitist. On show were three of the 'Six Projects', the portraits of his mother and Thomas Carlyle, of Frederick and Frances Leyland, and of Cicely Alexander. A considerable amount of space was devoted to graphic and decorative art, which included *Blue and Silver: Screen, with Old Battersea Bridge*, intended for Leyland.

Rossetti noted, perhaps a trifle nervously, that the exhibition would send Whistler 'sky-high, and Leyland will probably buy no one else any more!' Although there is no evidence that Leyland paid for the show, as Rossetti believed, Whistler found him the perfect client, willing to extend his patronage from commissioning portraits of himself and his wife, to those of his family of two daughters and a son. He would ask Whistler's advice on anything that concerned art and design old or new, from his wife's dress to the purchase of a portrait, possibly by Velázquez. For his part Whistler accepted Leyland's suggestion of the title 'nocturne', and called him the 'Liverpool Medici', with only a slight trace of irony.

At this time Whistler extended his modernity by making portraits of Connie Gilchrist, the skipping-rope dancer at the Gaiety Theatre. In the portrait *Arrangement in White and Black* (fig. 39), his mistress, Maud Franklin, wears the latest in figure-contricting costumes. The fashionable accessories and provocative poses of such portraits exceeded the conventions of formal portraiture of named sitters, and reflected a questioning by Whistler of the social and sexual proprieties of aristocratic and bourgeois life.[10]

In 1876 Whistler worked on decorations for the stairway of 49 Princes Gate, the London home of Leyland, who also agreed to his making minor modifications to the walls of the dining room to assist Thomas Jeckyll, who had designed delicately fretted shelving in the Japanese style with leather-lined walls to display Chinese porcelain and Whistler's *La Princesse du pays de la porcelaine* which hung above the fireplace (see fig. 9). Whistler far exceeded the commission without informing Leyland of his intentions. By the autumn he had painted the walls, shelving, ceiling and window shutters with an elaborate colour scheme based on the feathers of the peacock (fig. 40). He valued his

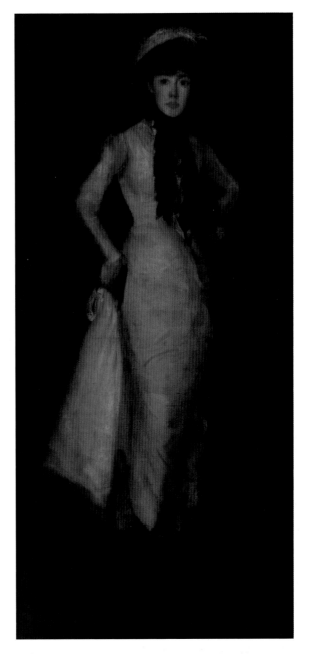

39 *Arrangement in White and Black*
*c.*1876
Oil on canvas
191.4 × 90.9
(75¾ × 35¾)
Freer Gallery of Art,
Smithsonian
Institution,
Washington, DC;
Gift of Charles Lang
Freer

work on the room at £2,000, claiming that the peacocks painted on the window shutters were alone worth £1,200. Leyland admitted that they might be worth as much 'as pictures', but asked for their removal as 'an expensive piece of decoration'. Having already advanced Whistler £400, he reasoned that 'the only way of arriving at a fair charge is to take the time occupied at your average rate of earnings as an artist', and sent Whistler a further cheque for £600. In acknowledging the payment and addressing Leyland as the 'British Business Man', Whistler noted that the payment was in pounds, as for a tradesman,

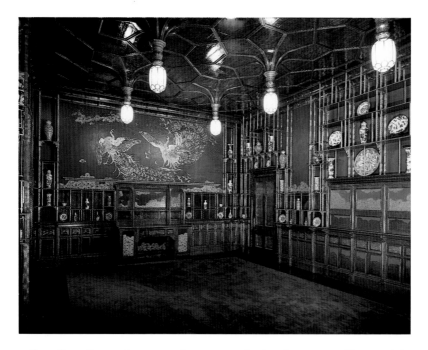

40 *Harmony in Blue and Gold: The Peacock Room* (view of south east corner) 1876–7
Oil paint and gold leaf on leather, canvas and wood
425.8 × 1010.9 × 608.3 (167⅝ × 398 × 239½)
Freer Gallery of Art, Smithsonian Institution, Washington, DC; Gift of Charles Lang Freer

rather than the customary guineas a professional man would expect to receive. Whistler represented the difference by painting silver shillings strewn at the feet of one of two peacocks on the south wall of the dining room, which he described in a letter to Leyland as symbolic of 'L'Art et L'Argent'. Among the many visitors to the press view, held in Leyland's absence in February 1877, was the fashionable preacher the Revd Hugh Reginald Haweis, who praised Whistler's representation of the peacock as 'this great irridescent work of God' in his sermon 'Money and Morals' preached at St James's Hall ten days later. Haweis took as his text 'Make to yourselves friends of the Mammon of Unrighteousness'.[11]

In his autobiography W.P. Frith made much of his 'discovery' of subjects of modern life, but failed to acknowledge that he owed his repeated success to what was materially and metaphorically a mechanical formula. Proud of his technical skills as a painter and his ability to simulate effects achievable by photography, he was anxious to disclaim any reliance on mechanical aids. He related, rather smugly, overhearing a 'respectably dressed woman' ask a man in front of his *Derby Day* (fig.41), which then hung in the National Gallery, 'I beg your pardon, sir, can you tell me if all this is *hand-painted*?' Frith's art, targeted at the multitude through engraving, was the antithesis of Whistler's, which was bought by a tiny minority. The mezzotints Whistler had engraved after the portraits of his mother and Carlyle were not a commercial success. But at the trial, driven by the need to exhibit public probity, Whistler claimed that proofs for the two portraits were 'all subscribed to' when the very reverse was true. He had to remind his solicitor that he was not 'in the position of the *popular* picture maker with herds of admirers', and that his art was 'quite apart from the usual stuff furnished in the mass'. In a time when the amassing of a fortune was considered socially respectable, to which Frith's three

volumes of memoirs attest, the effect was not only to make his art look superior to Whistler's, but to make himself socially superior to him too.[12]

Whistler's art operated at the opposite end of the market, by always emphasising less rather than more. By printing and personally supplying impressions of his own etchings, rather than selling to a dealer in a finite edition, he could create an illusion of authorial authenticity which the contracted mechanical product could not rival. In a nocturne, the paint appears to be running off the canvas. Like Frith's work, it was all hand-painted but, unlike Frith's, no one would think it was done in any other way. By drawing attention to the handmade aspect of his work, as opposed to the finished anonymity of a machine-made artefact, Whistler prioritised the conceptual role of the artist. This had traditionally been expected of the artist, but industrialisation radically eroded the division of labour required to make objects, including art. The grand houses and extravagant lifestyles of successful Victorian artists with their aristocratic pretensions, the colossal inflation in the English art market in the second half of the century, and the growing power of the dealer, all failed to mask the intellectual vacuity at the heart of much modern art in the closing years of the nineteenth century. In this respect Whistler's position was, paradoxically, not so dissimilar from that of Ruskin, although he profoundly disagreed with his moral philosophy of modern art and society. For unlike Ruskin who distrusted public taste, Whistler, a modern businessman like Leyland, was willing to exploit laissez-faire culture to promote his work, rather than passively disengage from the marketplace. But if Whistler's modernity was to be made socially acceptable, a critical consensus was needed to endorse its value. In mid-career this requirement brought Whistler and his art into direct conflict with the mainstream social and economic values of his time.[13]

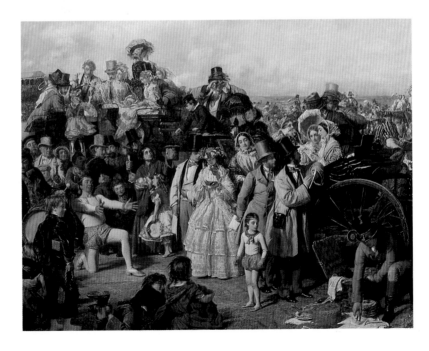

41 W.P. Frith
Derby Day 1856–8
(detail)
Oil on canvas
101.6 × 223.5
(40 × 88)
Tate

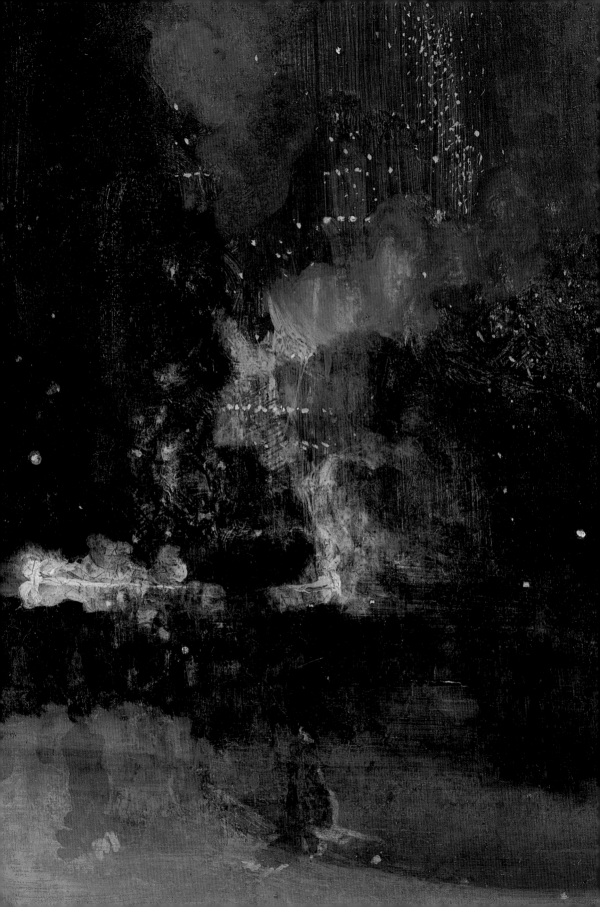

4

MORALITY

For Mr Whistler's sake, no less than for the protection of the
purchaser, Sir Coutts Lindsay ought not to have admitted works into
the gallery in which the ill-educated conceit of the artist so nearly
approached the aspect of wilful imposture. I have seen, and heard,
much of Cockney impudence before now; but never expected to hear a
coxcomb ask two hundred guineas for flinging a pot of paint in the
public's face.

(John Ruskin, Letter 79, *Fors Clavigera*, 1877)

In the summer of 1877 Whistler exhibited *Nocturne in Black and Gold: The
Falling Rocket*, a painting of fireworks against a night sky, at Sir Coutts Lind-
say's newly opened and luxuriously appointed Grosvenor Gallery. Although
no one doubts that Ruskin's criticism was sincere, it is difficult to know exact-
ly what he saw in 1877, because Whistler continued to work on the painting
until it left his hands for good in 1892. A close examination shows that he took
great pains with it; to what extent this represented work done before 1877 is
impossible to establish. It is also not clear how he achieved some of his effects,
especially that of the pearly grey smoke drifting across the black; the tech-
nique is more like watercolour than oil. For the smaller details such as the
bursting shells and trails of smoke he used very fine brushes, a technique sim-
ilar to the use he made of the burin for etching. The wood panel, and its red
ground, make an important contribution to the luminosity and depth of tone
he obtained for the shadowy darkness. Whistler exhibited *The Falling Rocket*
under glass, which is how he recommended it should be seen when he finally
sold it to the New York lawyer Samuel Untermeyer.

Although Ruskin's criticism was published in a pamphlet addressed to the
'workmen and labourers of Great Britain', it had a large circulation among
the middle classes. The criticism was widely syndicated in other publications,
so Whistler sued Ruskin for libel, claiming £1,000 damages, a decision wel-
comed by Ruskin who thought a trial would 'enable me to assert some princi-
ples of art economy which I've never got into the public's head, by writing, but
may get sent over at the world visibly in a newspaper report or two'. Barring
some unforeseen disaster or a totally incompetent performance by Whistler's
side, it was expected at the outset that Ruskin would lose. In the words of his
Counsel, 'their [the jury's] sympathies would rather lean to the side of the
man who wanted to sell his pictures than to the side of the outspoken critic
whose criticism interfered with the sale of a marketable commodity'.
Although Whistler did indeed win, it was a pyrrhic victory, for he was awarded
only a farthing's damages and had to pay his own costs, which accelerated his

42 *Nocturne in Black
and Gold: The Falling
Rocket c.1875*
(detail of fig. 37)

bankruptcy. The jury, while convinced of his argument, was unimpressed by his painting.[1]

Whistler's case was that Ruskin's criticism had damaged his livelihood, Ruskin's defence that his criticism was justified. Although the case has long been considered a watershed in the history of art, and a contest in which the freedom of the artist to paint how and what he wants was first fought and won, the central question, when it finally came to court, was whether Whistler's painting was worth the money he asked for it. While definitions of presumed artistic skill in painting naturally differed, the claims made for and against Whistler's art were in essence no different from those which had divided popular opinion on Turner, on whose merit Ruskin had first staked his reputation in *Modern Painters* thirty-five years earlier.

For the plaintiff, the art critic William Michael Rossetti, the artist Albert Moore and the playwright William Gorman Wills testified. Whistler claimed that only the professional practitioner of art, not the writer, was qualified to criticise painting. Under repeated examination by both sides he patiently reiterated that he had never intended *Nocturne in Black and Gold: The Falling Rocket* (fig.37) and *Nocturne: Blue and Gold – Old Battersea Bridge* (fig.6), which were in the courtroom, to be 'portraits' 'of a particular place', but rather 'artistic impressions' of the scenes. 'My whole scheme was only to bring about a certain harmony of colour.' 'I wished,' he told his Counsel, 'to indicate an artistic interest alone, divesting the picture of any outside anecdotal interest which might have been otherwise attached to it. A nocturne is an arrangement of line, form, and colour first. The picture is throughout a problem that

43 William Holman Hunt
The Shadow of Death
1869–73
Oil on canvas
212 × 166.4
(83½ × 65½)
Manchester City Art Gallery

I attempt to solve. I make use of any means, any incident or object in nature, that will bring about this symmetrical result.' On the question of price, both Rossetti and Moore agreed that if they could afford it they would gladly give 200 guineas for Whistler's picture, which Moore pointed out 'is paid for the skill of the artist, not always for the amount of labour expended'. The language Whistler used to defend his painting was unexceptional to anyone familar with the theory of art for art's sake – or the many purple passages in Ruskin's own writing. For liberal opinion, and the jury, such matters were less important than the formidable reputation of Ruskin, whose radical pronouncements on economics and society were of far greater public concern than his influence as an art critic. What it came down to for the defence was: could Ruskin get away with calling the shots?

In attempting to justify Ruskin's criticism as privileged his Counsel took every opportunity to suggest that Whistler's art was technically incompetent, because it fell short of accepted standards of 'finish'. Both sides tried to establish standards by which painting in general, and Whistler's in particular, should be judged, and how the price of a picture should be a fair reflection of the time and labour spent in its production, in Ruskin's words 'a fair day's wage for a fair day's work'. This prompted the Attorney-General Sir John Holker, in his cross-examination of Whistler, to ask him how long it took him to 'knock off' one of his pictures. On being told two days, he then asked him if it was the labour of two days for which he asked 200 guineas, to which Whistler gave his famous reply, 'No; – I ask it for the knowledge of a lifetime', which was received with applause in the courtroom.

Ruskin knew only too well that painting was exempt from the labour theory of value, that the considerations brought to bear on establishing its price could not be crudely quantified by the cost of the labour which went into making it, as it would have been for an industrial product in the time of Adam Smith, which the Attorney-General's question to Whistler implied. The price of a product, especially painting, could never truly reflect the cost of labour, because it was based on the margin the manufacturer, or dealer, calculated would make him a profit. Ruskin abhorred laissez-faire economics, which he believed were disastrous to society, the 'principle of death' and the cause of waste in artistic and all other work. He reluctantly accepted that the art world was predicated on the economics of 'modernism' – his word for everything that he detested about the modern world – which is partly why he increasingly affirmed the labour theory of value as a means of determining what he called the 'vital' value of art.

Ruskin's wish was to establish stable and lasting values in what he considered to be an age of rampant materialism. In whatever way an artist produced good painting, whether through spontaneous ease or slow laboriousness (he is often misunderstood as favouring only the latter), he viewed art through the paradigm of labour theory in order to assess its value.[2] However irrelevant the theory had become in practice, the work ethic itself was firmly entrenched in the public imagination and had been influentially promoted in modern society by Thomas Carlyle in his essay Past and Present (1843), and by Ruskin. Both men appear in Ford Madox Brown's urban narrative devoted to the subject,

Work, which had been exhibited in 1865. And Ruskin himself, in championing the minutely observed time-consuming painting of the Pre-Raphaelites, had more or less underwritten the principle of a time-based economy of art – even though he would have been horrified by the record price of William Holman Hunt's *The Shadow of Death* (fig.43) which was sold, with engraving rights, for 11,000 guineas, in 1873. Years later Hunt told Whistler's biographer Joseph Pennell that it had taken him three days to paint one of the shavings on the floor. 'H'm,' Whistler laughed when Pennell reported it to him, 'some people could have done it better in three minutes, and then wouldn't have said anything about it.'[3] Ruskin wrestled continually with these contradictions and made several attempts to arrive at a 'just' price for painting, including a consideration of its size, but he never arrived at a satisfactory formula to determine the relationship between intrinsic and exchange value. Six months before Whistler's libel case, Ruskin, who had only recently recovered from a serious mental breakdown (he would not appear in court), made one last-ditch attempt to prove his case.

He knew that his opinions and criticism influenced the art market, but had convinced himself that 'no artist has ever been suspected of purchasing my praise', though he had written fulsomely about Burne-Jones and given him financial support. While he made a distinction between dead and living artists, he was also aware that his practice of trading in Turner's work, which he was 'always glad to see going high', might not go unchallenged, for the case turned on the pecuniary damage Whistler alleged he had suffered as a result of Ruskin's criticism. Before the trial, he therefore took the opportunity of reminding the public why he accorded greatness to Turner's art, in whose defence he had made his debut as a critic in 1843, and by implication condemned Whistler's.

Ruskin had concluded the *Notes by Mr. Ruskin* that he wrote for the exhibition of Turner's watercolour drawings held by the Fine Art Society early in 1878, with the remark Turner made to the Revd W. Kingsley, who had asked him about the nature of genius: 'Turner said vehemently, "I know of no genius but the genius of hard work."' In his catalogue entries to the exhibition Ruskin made numerous observations on the different methods Turner used, and the effects he had achieved through 'hard work', a commodity Ruskin measured in terms of labour time to prove Turner's genius. A drawing by Turner may have a sky of 'hasty execution' but be 'quite faultless' over which twice as much time had beeen spent on the whole drawing than 'in the sky alone' in another. With reference to one drawing, Ruskin suggested that Turner had spent on it 'from twenty minutes to half an hour ... But, mind you, – the twenty minutes to half an hour, by such a master, are better in result than ten years' labour would be – only *after the ten years' labour* has been given first.'[4]

For the revised edition of the Turner catalogue Ruskin wrote an eight-page 'Epilogue' on ten Swiss watercolours Turner made in 1841–2. Their thirty-year history was 'illustrative of some of the changes which have taken place during that interval, in our estimate of the monetary value of a painter's toil'. He had been present when, early in 1842, Turner offered to paint ten Swiss watercolours for his dealer Thomas Griffith, for which Griffith said he could get

80 guineas each, including commission. Turner, who 'had expected a thousand, I believe', asked Griffith:

> 'Aint they worth more?'
> Says Mr Griffith to Mr Turner, (after looking curiously into the execution, which, you will please to note, is rather what some people might call hazy): 'They're a little different from your usual style' – (Turner silent, Griffith does not push the point) – 'but – but – yes, they are worth more, but I could not get more.'
> (Question of intrinsic value, and political economy in Art, you see, early forced on my attention.)

Ruskin further relates how in the 1870s he was approached by the dealer William Vokins who asked him for a 'first rate Turner drawing, had I one to spare?'

> 'Well,' I said, 'I have none to spare, yet I have a reason for letting one first-rate one go, if you give me a price.'
> 'What will you take?'
> 'A thousand pounds.'

Ruskin parted with *Lucerne from the Walls* (fig.44), because he 'wished to get *dead* Turner, for one drawing, his own original price for the whole ten, and thus did'.[5]

Ruskin's story illustrates the difference between the value of the Turner watercolours (what they were worth) and their exchange or market value (what Griffith could get for them). If Griffith could get only 80 guineas for each of them, but admitted, as he did to Turner and Ruskin in 1842, that their intrinsic value was more than 80 guineas, the question arose of how much more they were worth. Ruskin implied that the question was meaningless: the figure could be infinite, because the price of genius could not be calculated merely in economic terms. By asking £1,000 for one watercolour Ruskin did more than show the new inflated market price for Turner which the dealers were prepared to pay in the 1870s. Because he feared the public might think the absurd price of £1,000 for a 12 by 18-inch watercolour represented its true – its 'vital' – value, his 1842 conversation implied that it could just as well have

44 J.M.W. Turner
Lucerne from the Walls 1842
Watercolour with scratching out
29.5 × 44.5
(11⅝ × 17½)
National Museums
Liverpool (Lady
Lever Art Gallery,
Port Sunlight)

carried a £1,000 price tag then as it was to thirty years later. In other words, contrary to popular belief ('O, recusant British Public!'), the value of great art could never be measured by the economic laws of supply and demand. On the contrary, art's true, or 'vital', value was stable and absolute. It remained unaffected by the vagaries of fashion and finance, and must be impervious to criticism, however stringent.

For Ruskin, the artists Edward Burne-Jones and W.P. Frith, and the *Times* critic Tom Taylor appeared as witnesses at the trial. Prevaricating by faintly praising the nocturnes for their delicate ['feminine'] values of colour, Burne-Jones said they lacked the robust ['masculine'] attributes of drawing, form and composition, and were thus incomplete. By according them the status of sketches only, and relegating them to the realm of women's art and romantic fancy, he attempted to emasculate what Whistler had said were finished works of art. In his summing up Ruskin's Counsel attempted to characterise the nocturnes (and by implication Whistler) as 'unmanly' by describing their admirers as predominantly female, 'groups of artistic ladies – beautiful ladies who endeavour to disguise their attractions in mediaeval millinery, but do not succeed in consequence of sheer force of nature [laughter]'. Since Ruskin believed his duty was to 'rank an attentive draughtsman's work above a speedy plasterer's', and distinguish an 'Artist's work from the Upholsterer's', the hope was that Whistler's painting would be discredited as something other than art, that *ipso facto* Whistler was not an artist. When Burne-Jones was eventually asked whether he considered *Nocturne in Black and Gold* 'a work of art', he replied, 'No, I cannot say that it is.' Frith gave a similar reply. To Frith and Taylor the nocturnes were more like silk or 'delicately tinted wallpaper' than paintings by an artist. Whistler's Counsel tried to get Frith to admit a connection between Ruskin's criticism of Whistler and that of Turner's *Snow*

45 *Nocturne in Grey and Gold – Piccadilly* 1881–3
Watercolour on white wove paper
22.2 × 29.2
(8¾ × 11½)
National Gallery of Ireland

46 J.M.W. Turner
Snow Storm – Steam-Boat off a Harbour's Mouth
Oil on canvas
91.5 × 121.9
(36 × 48)
Tate

Storm (fig.46) in 1842 as 'a mass of soapsuds and whitewash'. Frith's response was that Turner's late works were painted when he was 'half crazy and produced works about as insane as the people who admire them [laughter].'[6]

In concluding his testimony for Ruskin, Burne-Jones had said he believed 'that if unfinished pictures become common we shall arrive at a stage of mere manufacture, and the art of the country will be degraded'. Unlike an upholstered sofa or a plaster wall, more than labour and finish were needed to make a work of art. Ruskin's witnesses suggested that Whistler's nocturnes, lacking even these prerequisites, could hardly even aspire to be products of 'mere manufacture'. Burne-Jones was voicing a belief central to Ruskin, Morris and their followers in the Arts and Crafts Movement, namely the superiority of the handmade artefact, coordinated by the eye and brain, over the soulless product manufactured by the machine. This was exactly what Whistler intended in his art. But because his critics could not see it they believed that a positive endorsement of his painting would threaten to unbalance this delicate relationship and precipitate the downfall of society. As Linda Austin observes, both Ruskin's term 'flinging' and the Attorney-General's 'knocking off' connote 'a romantic notion of spontaneous creation which is worthless in a society that valorizes the amount of work'.[7]

While today we may bristle at Ruskin's presumption, and find flaws in an argument which is no longer relevant to our society, we should pause before judging him a force of reaction and repression, and Whistler the revolutionary free spirit and advocate of artistic freedom. The verdict that the jury handed down to Whistler, with a farthing's damages, was not based on definitions of art, or the labour theory of value. It turned rather on 'marginal utility', which recognises that price alone dictates the cost of goods, a principle of the modern laissez-faire economy Ruskin totally opposed but which by the 1870s was impossible to reverse. Although we have found this an acceptable way to price and buy goods for more than a century, some of us still have difficulty valuing art on this basis, perhaps because of a residual instinct which tells us that art should be about something more than money. Since Whistler sued Ruskin, how often has the time taken to produce a work of art not been relevant to an assessment of the price that is asked for it? Dealers still value nine-

teenth-century art in these terms. In the twentieth century, Henri-Pierre Roché said of his friend Marcel Duchamp – the creator of the ready-mades including the infamous *Fountain* of 1917 – that his greatest achievement was his use of time. Today the subject of an artist's video, and other forms of performance and conceptual art, is very often time itself (fig.47).

In suing Ruskin, Whistler did not seek a role for the artist outside society. On the contrary, his case was to have his professional role within it accepted. If this had not been recognised he would have lost not only his costs and damages but the case as well. In his first brown paper pamphlet, *Whistler v. Ruskin. Art & Art Critics*, dedicated to Albert Moore and published within a month of the trial, Whistler reiterated his belief that only a practising artist was qualified to criticise art. He characterised his action against Ruskin as one 'between the brush and the pen', and henceforth dedicated himself to waging a war against art critics.[8] In assuming the role of critic, Whistler became the patron saint of all professional artists, for few artists then or since would disagree with his statement to Ruskin's Counsel that 'it is not only when a criticism is unjust that I object to it, but when it is incompetent'. One such artist is R.B. Kitaj (fig.48), like Whistler an American long resident in London, and who in his time has received more than his share of incompetent criticism and ignorant abuse. Like Whistler, he is not prepared to take it lying down. In his painting Kitaj shows himself as the referee, in George Bellows's boxing ring, counting Ruskin out after Whistler delivers the knockout blow. What Whistler fought for more than a century ago is far from forgotten. In Kitaj's words, 'the issues are still electric today'.[9]

5

PERFORMANCE

When Whistler went to Venice in 1879 he not only had twelve etchings to make for the Fine Art Society, but he also wanted to bring back other work, and so he extended his stay by several months. Venice was so well known and visited that Whistler had to find new subject matter and depict the city in a different way (fig.49). What he did in Venice also reflected his recent experiences at home. Some of his etchings of early Renaissance buildings were remarkably detailed, as though they were intended to show Ruskin that he could draw architecture. He could not, either with etching or with pastel, avoid the famous views of the Salute and San Giorgio, which great artists of the past had painted, including Turner. With one or two views Whistler also paid homage to Canaletto, whom he thought vastly superior to Turner, but whom Ruskin hated. The Venice Whistler therefore brought back to London in his pictures was essentially of two types: the private and the public.

The Piazzetta (fig.50) was exhibited as one of Whistler's 'Twelve Etchings of Venice' in December 1880; *Nocturne: Salute* (fig.51) was not. Alastair Grieve has described the nocturne as an etching for the avant-garde, 'the sensitive, the few, who respond to one of Nature's rare moments of exquisite beauty, when, for once, [as Whistler said in the 'Ten O'Clock'], "she has sung in tune"', and *The Piazzetta* as 'a set piece, a summer's day scene recognizable to any tourist who may have sat at a café in that magnificent theatre'. It is almost as if, compared to the wide outdoors suggested by *Nocturne: Salute*, *The Piazzetta* is an indoor subject. Making a relationship between indoors and outdoors became a strategy Whistler adopted for his art when he returned from Venice. The relationship between his private and public self also served a similar purpose when he told his biographers 'I have no private life!' Whether a private view of an exhibition, or personal correspondence with Oscar Wilde, published in *The World*, the paradox was that it was all very public.[1]

Whistler involved himself at every stage in the process of planning an exhibition. Printing the etchings, choosing the contents and framing the work were only the beginning. He would personally supervise gallery workmen, frame-makers and printers. He trained, for instance, one member of a firm to put a touch of colour on the butterfly on each private view card by hand. Whatever the decorative scheme, the exhibition occupied a private space which had to relate to the public world outside. For the scheme in flesh colour and grey for his exhibition of *Notes – Harmonies – Nocturnes*, held at Dowdeswell's Gallery in 1884, Whistler insisted, according to Mortimer Menpes, on the 'colour scheme overflowing a little into Bond Street and oozing-out via the "chucker-out" whose uniform was to be grey with flesh-coloured facings'. When all the pictures were hung Whistler would give his helpers dinner

51 *Nocturne: Salute*
1880
Etching; dark brown
ink on white laid
paper
15.3 × 22.7 (6 × 9)
Hunterian Art
Gallery, University of
Glasgow. Birnie
Philip Bequest

Opposite left
49 *Beadstringers*
1880
Chalk and pastel on
golden-brown paper
27.6 × 11.7
(10 × 4⅝)
Freer Gallery of Art,
Smithsonian
Institution,
Washington, DC;
Gift of Charles Lang
Freer

Opposite right
50 *The Piazzetta*
1880
Etching and
drypoint; dark
brown ink on white
laid paper
25.8 × 18.1
(10⅛ × 7⅛)
Hunterian Art
Gallery, University of
Glasgow

at the Arts Club the night before the opening, when the prices would be decided; under the influence of alcohol they rose stratospherically. The next morning, before the press arrived, he would call for ladders and in front of a small audience paint a large butterfly on the wall, to 'pull the exhibition together', an act which emphasised the performative nature of the proceedings. When the press arrived he would have whisky ready for the journalists, and show them, by smell and touch, the difference between an oil and a pastel, and then dictate to them what they should write.[2]

Whistler's first exhibition of Venice etchings in 1880, and second in 1883, *Venice Etchings and Drypoints*, were held at the Fine Art Society, ironically in the same rooms in which Ruskin's exhibition of Turner's watercolours had been mounted in 1878. At the private view in 1883 the guests were 'enraged, amused and interested', not least because, on a chill February Saturday afternoon, they were kept waiting outside in the street for more than an hour while Whistler conducted the Prince and Princess of Wales round the exhibition. When the royalty had departed the 'crowd pushed its way in', to find

> a symphony in yellow and white. The walls yellow and white, the
> doors curtained with yellow; stands of yellow flowers, in yellow pots,
> in the corners; a footman, in splendid livery of yellow plush, handed
> [out] catalogues. It was impossible to see the Master's works for the
> numerous waiting admirers congregated around them ... Lady
> Archibald Campbell bravely sported the colours of the artist who has
> lately decorated her beautiful house. A yellow butterfly was in her hat
> of Canadian fur, another was pinned to her fur cloak. She carried
> some yellow flowers in her hand.[3](fig.52)

52 *Designs for Lady
Archibald Campbell's
Parasol* c.1881–2
Pencil and
watercolour on off-
white wove paper
29.3 × 23.2
(11½ × 9⅛)
Hunterian Art
Gallery, University of
Glasgow. Birnie
Philip Bequest

It did not matter if the guests could not see the works properly. What was more important was that they knew what others thought about them. The catalogue, *Caviare to the Critics*, humorously informed them, by reprinting snippets of past criticism accompanied by acidic comments from Whistler.

Whistler went for maximum impact with minimum means. Whereas before, the labour theory of art had been used against him, he now subverted it for his own ends. Landscape and marine paintings, previously of a conventional size, were reduced to the format of *Notes* and *Harmonies* measuring only a few inches across. By exhibiting them in deep frames, with a short focal length, Whistler ensured that the viewer became simultaneously involved in brushstroke and subject. He focused attention on what he had taken back into his control, by giving equal attention to both treatment and subject, whether a shop-front, a wave, or a pretty girl. An anonymous admirer quoted by the Pennells asked Whistler the price of a pastel, and when told exclaimed, 'Sixty guineas! That's enormous!' To which Whistler replied, 'Enormous! Why not at all! I can assure you it took me quite half an hour to draw it!'[4]

Whistler's sea and landscapes on a tiny scale (fig.53) were probably influenced by Constable's *plein air* oil studies, which had recently been acquired by the South Kensington Museum, although he affected to dislike Constable, as we shall shortly see. The landscapes were also a parody of what the critics thought Impressionism was about. When he was in St Ives early in 1884 he went off on his own surreptitiously with a little paintbox and small panels to make seascapes in oil and watercolour for his exhibition at Dowdeswell's Gallery the following May. The 'professional' Impressionists working in St Ives, with their umbrellas and elaborate painting paraphernalia, thought he was an amateur. Whistler's Impressionist parodies were very timely. Early in 1883, Dowdeswell's Gallery held an exhibiton of French paintings by Boudin,

53 *The White House*
c.1884–5
Oil on wood panel
13.6 × 23.6
(5⅜ × 9¼)
Freer Gallery of Art,
Smithsonian
Institution,
Washington, DC;
Gift of Charles Lang
Freer

Cassatt, Degas, Renoir, Manet, Monet, Morisot, Sisley and Pissarro. The amount of attention it received rivalled Whistler's show of Venice etchings, which opened down the road a week or two later. Even Whistler's adversary, the critic Frederick Wedmore, took Impressionism seriously, and wrote a long article about it in the heavyweight *Fortnightly Review*. It was no coincidence that, of all the journalists Whistler mocked in *Caviare to the Critics*, Wedmore was by far the most reviled. He is quoted (and deliberately misquoted) no fewer than fifteen times. Inevitably, Whistler was identified as an Impressionist. The 1884 exhibition *Notes – Harmonies – Nocturnes* at Dowdeswell's included the first showing of his watercolours in any numbers. The 'Propositions – No.2' issued with the catalogue is a summary of Whistler's programme – and his answer to Impressionism – as well as Ruskin:

> A picture is finished when all trace of the means used to bring about the end has disappeared. To say of a picture, as is often said in its praise, that it shows great and honest labour, is to say that it is incomplete and unfit for view. Industry in Art is a necessity – not a virtue – and any evidence of the same, in the production, is a blemish, not a quality; a proof, not of achievement, but of absolutely insufficient work, for work alone will efface the footsteps of work. The work of the master reeks not of the sweat of the brow – suggests no effort – and is finished from its beginning ... The masterpiece should appear as the flower to the painter – perfect in its bud as in its bloom – with no reason to explain its presence – no mission to fulfil – a joy to the artist – a delusion to the philanthropist – a puzzle to the botanist – an accident of sentiment and alliteration to the literary man.[5]

In the 1870s Whistler's modernity as a portrait painter had been defined by his choice of unknown subjects, drawn from his own circle – like Maud Franklin – and sitters from the theatre and demi-monde. His portraits of the 1880s reflected a wider social range of subjects. Lady Meux, before her marriage to the brewer, had enjoyed a racy street life, and was susceptible to flattery with a series of formal portraits to display her furs and jewels. In 1884 Théodore Duret described *Arrangement in Black: The Lady in the Yellow Buskin (Lady Archibald Campbell)* (fig.54), shown at the Salon, as 'meeting all the conditions of great art, [with] its formal originality and background, inventive subject and simplicity of execution'. The sitter's family was less convinced. They rejected it 'with the delicate remark that it represented a street walker encouraging a shy follower with a backward glance'.

While sparring with Wilde in the *World*, Whistler was also entertaining Duret in London, to whom he had been introduced by Manet in 1880. In return for his hospitality, Duret helped Whistler stage his reappearance in Paris, where he began to exhibit again in 1882 after an absence of more than a decade. In his article on Whistler for the *Gazette des Beaux Arts* in 1881 Duret compared Whistler's nocturnes to the harmonic fragments of Wagner's music, and wrote of *Nocturne: Grey and Silver*, which he owned, as arriving 'at the outermost margins of formalized painting. One step nearer and there would be nothing on the canvas except a formless blob, incapable of impart-

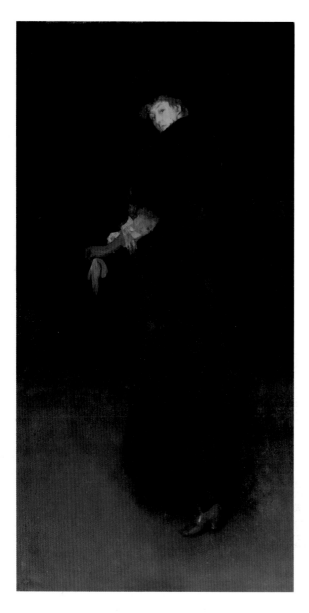

54 *Arrangement in Black: The Lady in the Yellow Buskin (Portrait of Lady Archibald Campbell)*
c.1882–3
Oil on canvas
218.4 × 110.5
(86 × 43½)
Philadelphia Museum of Art. Purchased with the W.P. Wilstach Fund, 1895

ing anything to the eye and mind.' When Duret republished his essay in his volume of collected art criticism, *Critique d'Avant-garde* (1885), Whistler wrote to thank him: 'and what a perfect title, l'Avant Garde – c'est ça – Voilà qui est bien trouvé. For let us never forget that you were always to the fore, while the others were left away behind in the dim distance of doubt and stupidity.'⁶

In London it was Wilde, associated with Whistler since they were both represented on stage in Gilbert and Sullivan's *Patience* (1882), who more than anyone else made art, in the words of the 'Ten O'Clock' lecture, 'a sort of common topic for the tea table'. Whistler had initially been willing for Wilde to be his 'St John'. In an exchange of telegrams in the *World* in 1883, Wilde, in response to a report of their conversation in *Punch*, wrote: 'When you and I

are together we never talk about anything but ourselves'; to which Whistler replied: 'No, no, Oscar, you forget – when you and I are together, we never talk about anything except me.'[7] Whistler soon grew to resent Wilde's appropriation of his ideas, about house decoration and similar subjects, on which he lectured; for Wilde followed Ruskin in seeing art as a reflection of society. Whistler, for his part, increasingly sought to liberate his art from it.

In the 'Ten O'Clock' lecture Whistler dissociated himself from romanticised accounts of the past, for 'were we to do without haste, and journey without speed, we should again *require* the spoon of Queen Anne, and pick at our peas with the fork of two prongs. And so, for the flock, little hamlets grow near Hammersmith, and the steam horse is scorned.' In denouncing the 'false prophets' who had brought 'the very name of the beautiful into disrepute', he rejected a contextualised view of art and society. Although he detested the philosophy of progress, Whistler inherited his objection to it from Poe and Baudelaire, not from Ruskin and Morris. For Whistler, the artist stood apart 'in relation to the moment at which he occurs – a moment of isolation – hinting at sadness – having no part in the progress of his fellow-men'. In his review of the lecture Wilde wrote that an artist could 'no more be born of a nation that is devoid of any sense of beauty than a fig can grow from a thorn or a rose from a thistle'. He disputed Whistler's authority – as a painter – to speak for art, claiming that the poet was 'the supreme artist ... and so to the poet beyond all others are these mysteries known; to Edgar Allan Poe and to Baudelaire; not to Benjamin West and Paul Delaroche'. It was not the comparison with West and Delaroche that Whistler objected to, but the challenge to his descent from Baudelaire and Poe.[8] Much worse was to come.

In his lecture Whistler said that although a writer might use poetic words to describe a painting, 'the *painter's* poetry is quite lost to him'. It was the '*painter's* poetry' Swinburne could no longer 'see' in Whistler's art, when he wrote a review of the 'Ten O'Clock' for the *Fortnightly Review* in 1888, which ended their friendship of a quarter of a century. Swinburne's knowledge of the visual arts had not advanced since the 1860s. He felt more comfortable with Ruskin and Burne-Jones, and had also acquired imperialist views, which Whistler would have found unappealing. Schooled in Sophocles and Aeschylus, he could not accept Whistler's thesis that Japanese art was the equal of Greek. He thought it primitive. For Swinburne, art had to be more than 'just decorative'. Whistler's 'principle of artistic limitation', he wrote, would 'condemn high art', including Greek sculpture and Velázquez, 'art which may be so degenerate and so debased as to concern itself with a story': 'Assuredly, Phidias thought of other things than "arrangements" in marble – as certainly as Aeschylus thought of other things than "arrangements" in metre.' He believed that Whistler's argument was not supported by the evidence of his work, for were not the portraits of his own mother and of Carlyle more than merely 'decorative'? They 'actually appeal to the intelligence and the emotions, to the mind and heart of the spectator'. But for Swinburne Whistler's nocturnes and oil sketches did not possess these qualities; for him they were the 'merest "arrangements" in colour' (fig.55) and, unlike the portraits, he argued, could never be described as being anything more than 'lovely and

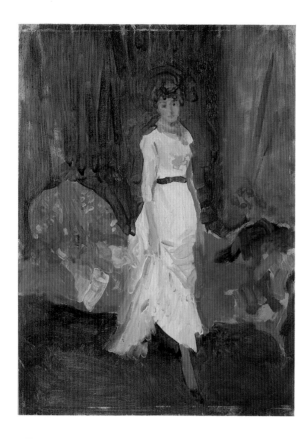

55 *Arrangement in
Pink and Purple*
*c.*1885
Oil on wood panel
30.5 × 22.9 (12 × 9)
Cincinnati Art
Museum, John J.
Emery Fund

effective'. They existed only as paint, lacked any intellectual content, and were
no more than decorative objects. This struck at the very heart of Whistler's
programme. 'Because the Bard is blind, shall the Painter cease to see?'
Whistler thundered. 'I have lost a confrère; but, then I have gained an
acquaintance – one Algernon Swinburne – "outsider" – Putney.' In the year
that Gauguin painted *The Vision after the Sermon*, and Mallarmé translated the
'Ten O'Clock', Whistler implied that Swinburne had taste only for the worst
kind of modern painting, the trivial and the anecdotal, which appealed to the
masses, for which Whistler believed Ruskin was ultimately responsible.[9]

Mallarmé, like Whistler in painting and drawing, sought to express in verse
sensations previously unknown to literature. Ironically, it was probably Swin-
burne who brought Whistler to Mallarmé's attention in the first place. In a let-
ter to Mallarmé in 1875 thanking him for his translation of Poe's 'The Raven',
with Manet's illustrations, Swinburne described how Whistler and Fantin-
Latour had introduced him to Manet in Paris in 1863. Swinburne also sent his
poem 'Nocturne' to Mallarmé, who published it in *La République des lettres* in
1876, the year Mallarmé's essay *The Impressionists and Edouard Manet*, which
mentions Whistler, was published in English.

Their collaboration was published in *The Whirlwind: A Lively and Eccentric
Newspaper* in 1890. The paper had as its masthead a lightly clad dancer in a
swirl of muslin which provided Mallarmé with the image for his poem 'Billet à
Whistler', printed alongside Whistler's lithograph *The Tyresmith*. In the poem

the dancer, a 'tourbillon de mousseline', tears up a street of black flying hats, a reference to Whistler's lithograph *The Winged Hat* (fig.56), which Mallarmé had admired in an earlier issue. She scatters everything and everyone in her wake save Whistler, whom she fans with her skirts. In an unsigned editorial in the *Whirlwind* Whistler conceded to Mallarmé 'the position of the most *vingtième siècle* poet in France ... the *raffiné* Prince of "Decadents" – the classic of Modernity'.[10] Mallarmé and Whistler shared an interest in the subject of the dance; the figures Whistler drew in the 1890s included Loie Fuller. The draped models, standing and reclining, in lithographs and pastels, echo the themes of the 1860s, when Whistler had evoked the verse of Swinburne and Poe in his art. However, the synaesthetic Neo-Classicism of the early drawings seems dry and laboured compared to the rich inventiveness and gem-hard brilliance of the later work, for which Whistler had Mallarmé to thank. They also shared an interest in costume, and Whistler no doubt knew *La Dernière mode*, the fashion and literary magazine for female readers Mallarmé edited in 1874. After they met in 1888 Whistler began to use items of dress or fashion accessories to complement the titles of his female portraits: *Arrangement in Black and Brown: The Fur Jacket*; *Arrangement in Black: La Dame au brodequin jaune (The Lady with the Yellow Buskin)* (fig.54); *Gants de suède*; *The Winged Hat* (fig.56); *The Felt Hat*; *Rose and Red: The Little Pink Cap* (fig.57); *The Jade Necklace*. Such seeming inconsequential items of feminine apparel had as much poetic significance for Mallarmé's verse as their line and colour had for Whistler's

painting and drawing – while for Swinburne they could only ever be 'lovely and effective'.

Whistler told Mallarmé that he saw in him his 'second self ... alone in your Art as I am in mine', while Mallarmé told Whistler that he saw in him a resemblance to Poe, 'alone as Edgar Poe must have been' Whistler confided in him after the death of his wife in 1896.[11] With their extreme elitist attitude to art and society they complemented one another perfectly. In art they shared a mutual respect for the technical processes of their respective crafts. Both were quite literally possessed by their work, and both laboured long and hard in private to bring it to fruition. The sittings for Whistler's lithograph portrait of Mallarmé for the frontispiece of *Vers et prose* (1893) (fig.58) were gruelling and painful. Henri de Régnier recalled Mallarmé telling him that Whistler posed him too near the fire and, pre-occupied with his drawing, would not let him move until he had finished, by which time his legs had been burned. Of the result, Duret wrote: 'Those who have known him can believe they hear him speak. Neverthleless the image exists only as a breath. It is built up by the most rapid pencil strokes. It is an improvisation, and yet one does not improvise so striking a rendering of a human being; it is necessary to have penetrated him profoundly to give him this intensity of life and character.'[12]

Duret's description of the portrait captures its duality of effect. It is so lifelike that Mallarmé might almost be heard to speak, yet it is only an image made of 'rapid pencil strokes'. Others who knew Mallarmé made similar observations about the portrait. Those who sat for Whistler went through similar experiences as Mallarmé. Comte Robert de Montesquiou (fig.59), who was Huysmans's model for des Esseintes in the first 'decadent' novel *A Rebours* (1884) as well as Marcel Proust's Baron Charlus, felt when he sat for his portrait that the fixity of Whistler's attention was 'drawing the life from him' and 'sucking something of his individuality'. He felt so drained, 'a sort of contraction of his whole being', that only the discovery of a wine made from coca helped him recover from those 'terrible sittings'. In his valedictory poem to Whistler, Montesquiou likens his own portrait, for which he had more than a hundred sittings, to Shelley's Zoroaster, who met his own image walking in the garden, and to Poe's ghost of William Wilson seen in the mirror: 'The eyes that no one but you can create / Eyes mourning the night and the day's course to sever / Eyes fixed on the sitter to whom you relate / "Look once more at me, and you will live forever".'[13]

In an age when the 'coloured photograph kind of thing' passed for art, Mallarmé and Whistler sought something very different. A question that con-

58 *Stéphane Mallarmé, No. 1* 1892 Lithograph; grey-black ink on cream laid paper 9.5 × 7 (3¾ × 2¾) Hunterian Art Gallery, University of Glasgow. Birnie Philip Bequest

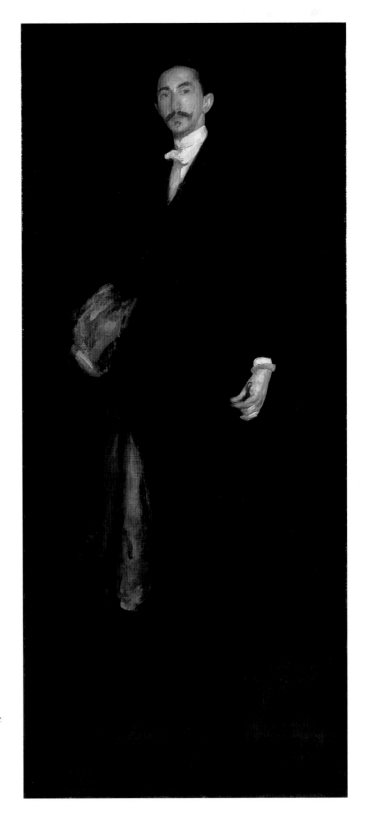

59 *Arrangement in*
Black and Gold:
Comte Robert de
Montesquiou-Fezensac
1891–2
Oil on canvas
208.6 × 91.8
(82½ × 36⅛)
The Frick Collection,
New York

cerned them was one which would often be asked about twentieth-century art: to what extent is art an expression of the artist who makes it? In the literary pendant to Whistler's portrait of him, published in *Divigations* (1899), Mallarmé suggested that if art can reveal the secrets of eternal beauty the identity of the artist who makes it is irrelevant. A work of art must be autonomous and have a life of its own, but this can be achieved only through a paradox. The artist has to be so obsessed with his art that he pours his entire being into his work. In the case of Whistler, he 'breaks out into the vital contempt which the black garments provoke against the radiance of the linen like the whistling of laughter'. It was therefore neither possible, nor relevant, to ask who Whistler was, since all there was to know about him was in his art. Whistler and Mallarmé thus anticipated the anonymous art, without artists, which Duchamp and his followers created in the twentieth century.[14]

Whistler would have rejected Arthur Symons's belief, expressed in his essay of 1906 (see epigraph to Chapter 1), that his aim, 'as of so much modern art', was 'to be taken at a hint, divined at a glance, or by telepathy'. For Whistler the subjective response of the viewer was unimportant. Painting was the very opposite of a 'hit and miss' affair, and never the result of chance, which later became a defining feature of much modernist art. If the artist achieved a chance result, he always told his pupils, it amounted to nothing more than 'trickery', for the artist must be in command of his materials and techniques at all times.

Increasingly in his late painting Whistler sought to create brushwork with the invisible facture of the old masters. Already in the 1880s he was becoming selective, examining a picture by Terborch in the National Gallery for the way a tiny face or a piece of flesh was painted. He would barely look at the rest of the picture. 'He's got it this time,' he told Menpes, 'but he does not understand blacks.' In his art Whistler took on Turner only on his own terms, on a miniature scale (see figs.45–6), but in front of the real thing in the National Gallery he was always critical: 'No: this is not big work. The colour is not good. It is too prismatic. There is no reserve. Come from this work, which is full of uncertainty. Come and look at the paintings of a man who was a true workman.' So saying, he led Menpes straight to a Canaletto: 'Now, here is a man who was absolute master of his materials. In this work you will find no uncertainty.' Whistler would not even look at Reynolds or Gainsborough. As for Constable, 'yes,' he said thoughtfully, 'what an athletic gentleman he must have been! And how enamoured he evidently was with his palette knife! Many a happy day, I warrant, Constable spent with that palette knife, and then – O dear! the country – how wearied one must get of green trees!' Just as they were leaving the gallery Whistler caught sight of a row of Turners. 'What a series of accidents!' Menpes heard him murmur.[15]

Like Mallarmé in verse, Whistler demonstrated that significant expression could be achieved with minimal means. In his Salon review of 1859, which contained his famous defence of the Imagination, the 'Queen of the Faculties', Baudelaire had written, quoting Poe's 'Morella', that it was 'a happiness to dream, and it used to be glorious to express what one dreams. But I ask you! Does the painter still know this happiness?'[16] Whistler, more than any artist of

60 *The Embroidered Curtain* 1889
Etching and
drypoint; brown ink
on white laid paper
23.8 × 15.8
(9⅜ × 6¼)
Hunterian Art
Gallery, University of
Glasgow

his generation, provided an answer to this question during a career which spanned the Naturalist and Symbolist movements in art and literature. His evocative elusive colours had an immediate appeal for the Symbolist generation, for whom Swinburne's concept of the decadent poet as the 'perfect artist' – represented by Mallarmé – had become fashionable.

While his French Impressionist contemporaries contested the value of academic painting, Whistler's contribution was to push the conventions of representation to their limit, while strengthening the principles of decorative art sanctioned by tradition. The atelier Whistler opened in Paris in 1898 called the Académie Carmen was attended by students from Europe and the United

States in large numbers. In England, Ireland and Scotland younger artists readily responded to his art and ideas. His influence on American Impressionism was formative; and in Germany, Scandinavia and Spain as well as Russia, if less so in France, Whistler's modernity made an immensely strong impact. The recent exhibition 1900, organised by the Royal Academy for the year 2000, showed just how widespread his influence was in Europe and beyond. From the 1880s the atmospheric nocturnes were a challenge to photographers such as P.H. Emerson, whose work Whistler admired; and on the American pictorial photographers Alvin Langdon Coburn and Alfred Stieglitz his influence was decisive. Yet for artists – whether painters or photographers – who saw in Whistler only what was 'lovely and effective' his influence was deadly. In the art magazines of the early 1900s are an endless succession of empty seascapes, vacuous nocturnes and tastefully arranged tonal interior subjects.

Early in 1905 a memorial exhibition of Whistler's work was held at the Ecole des Beaux-Arts in Paris. No greater contrast is imaginable than between Whistler's pearly greys and browns (fig.60) and the colour revolution of Fauve painting which exploded later the same year at the Salon d'automne. It put an end to Whistler as a serious contender to influence the course of modern painting. But the two critical issues that confronted the Fauvist canvases of Derain and Matisse (fig.61) in 1905 were exactly what Whistler had addressed in his art and insisted upon time and again in his writing: the relationship of modernity to tradition, and the question of art as decoration. On this ground, more than any other, the values of modern painting have been contested since.[17]

61 Henri Matisse *Woman beside the Water (La Japonaise, Mme Matisse), Collioure* 1905 Oil and pencil on canvas 35.2 × 28.2 (13⅞ × 11⅛) The Museum of Modern Art, New York. Purchase and partial anonymous gift

Whistler's most enduring legacy is often said to be his ideas rather than his art. Writers are more interested in making connections between artists, whereas painters are more likely to think of their differences. Proust, an admirer of Ruskin as well as of Whistler, felt the conflict between writer and painter could be reconciled. He believed that, while Whistler had been right to hold that art was distinct from morals, he also felt, like Ruskin, that all great art was moral. In his intentionally bare room, Proust had a single reproduction of a work of art, a photograph of Whistler's *Arrangement in Grey and Black, No.2: Portrait of Thomas Carlyle*. Elsewhere, Whistler's portrait was literally assumed by the American Imagist poet Ezra Pound who had himself photographed in the same pose. An exhibition of Whistler's work at the Tate Gallery in 1912 made a deep impression on him. He received from it 'more

courage for living than I have gathered from the Canal Bill or from any other manifestation of American energy whatsoever'. For Pound, who was also thinking of Poe, Whistler had 'all our forces of confusion within him ... the drawbacks and hindrances at which no European can more than guess ... He is, with Abraham Lincoln, the beginning of our Great Tradition.'[18]

The refinement and self-conscious elegance of Whistler's work contrasts strongly with the iconoclastic art which reflected the social and political tensions of the twentieth century. By the time of the First World War, Cubism and Futurism were a truer reflection of the age. Whistler's excessive cult of the artist was inimical to modernism's search for the different set of universal values which the new century required. When Clive Bell published his theory of 'significant form' in *Art* (1914), he turned not to Whistler, but to Cézanne, Gauguin and Matisse to make his case. However, the distinction Whistler made between art and literature remained, and Clement Greenberg's modernists were still clinging to it in the late twentieth century. Without Whistler, painting *as art* would have lost its role and become only a vehicle for reproduction, inferior to an experience at the cinema. Whistler put the art back into painting and give it a new lease of life, an influence which artists from Walter Sickert and Pablo Picasso to Francis Bacon could not have done without.

62 Pablo Picasso
Landscape at Céret
(Paysage de Céret)
summer 1911
Oil on canvas
65.1 × 50.3
(25⅝ × 19¾)
Solomon R.
Guggenheim
Museum, New York.
Gift, Solomon R.
Guggenheim, 1937

Chronology

The information given here is largely derived from the extended chronologies in Andrew McLaren Young et al., *The Paintings of James McNeill Whistler*, New Haven 1980, I, pp.lvii–lxii and Margaret F. MacDonald, *James McNeill Whistler: Drawings, Pastels, and Watercolours: A Catalogue Raisonné*, New Haven 1995, pp. xxxii–xli.

1834 – James Abbott Whistler born on 11 July, third son of Major George Washington Whistler, civil engineer, and eldest son of his second wife, Anna Matilda McNeill, of Irish and Scots ancestry.

1837–40 – Lives in Stonington, Connecticut, and Springfield, Massachusetts, where his father is engineer on the Western Railroad.

1843–8 – Lives in St Petersburg where his father is engineer on the St Petersburg to Moscow railroad. Attends drawing lessons at the Imperial Academy of Fine Arts.

1847 – Groomsman at the wedding of his half-sister, Deborah, and Francis Seymour Haden, in Preston, Lancashire.

1848 – Visits the Hadens in London and spends a term at school in Bristol.

1849 – Stays with the Hadens in London, and then lives in Pomfret, Connecticut.

1851 – Enters West Point Military Academy.

1854 – Discharged from West Point. Works at locomotive works in Baltimore; then appointed to drawing division of the United States Coast and Geodetic Survey, Washington, DC.

1855 – Arrives in Paris and in 1856 enters the studio of Charles Gleyre. Meets George Du Maurier, Thomas Armstrong, Edward Poynter and other English artists.

1858 – Publishes the 'French Set' of etchings. Formation of the Société des Trois ('Society of Three'): Fantin-Latour, Whistler and Legros.

1859 – His painting praised by Courbet. Moves to London, staying with the Hadens, but in the following years regularly visits Paris. Begins the 'Thames Set' series of etchings.

1860 – *At the Piano* exhibited at the Royal Academy. Johanna Hiffernan becomes his mistress and principal model.

1861 – Visits Brittany. Paints *The White Girl*, later called *Symphony in White, No. 1: The White Girl*, in Paris. Exhibits at the Royal Academy.

1862 – Thames etchings exhibited in Paris and praised by Baudelaire. *The White Girl* rejected by the Royal Academy. Paints seascapes at Guéthary, Basses-Pyrénées. Meets Swinburne and Rossetti.

1863 – Moves to 7 Lindsey Row, Chelsea. *The White Girl* exhibited at the Salon des Refusés; exhibits at the Royal Academy. Mother comes to live with him.

1864 – Poses with Manet, Baudelaire and others for Fantin-Latour's *Hommage à Delacroix*. Exhibits at the Royal Academy.

1865 – His brother, Dr William Whistler, comes to live in London. Albert Moore replaces Legros in the 'Society of Three'. Exhibits at the Salon and the Royal Academy. Paints at Trouville with Courbet.

1866 – Travels to South America.

1867 – Moves to 2 Lindsey Row, Chelsea. Violently assaults Seymour Haden in Paris. Exhibits at the Salon and *Exposition Universelle*; shows *Symphony in White No. 3* at the Royal Academy. Writes to Fantin-Latour rejecting Courbet's Realism, and wishing he could have studied under Ingres. Expelled from Burlington Fine Art Club because of the Haden affair.

1870 – Birth of Charles Whistler Hanson, child of Whistler and Louisa Hanson. Exhibits at the Royal Academy.

1871 – Publishes *Sixteen Etchings of Scenes on the Thames* and begins a succession of Thames nocturnes. Paints *Arrangement in Grey and Black*, exhibited at the Royal Academy the following year and his last submission. Begins to exhibit in small London dealers' shows.

1873 – Exhibits recent work at the Galerie Durand-Ruel, Paris. Initiates his midday 'Sunday breakfasts'. Maud Franklin takes Jo's place as Whistler's mistress and chief model.

1874 – One-man show in the Flemish Gallery, Pall Mall.

1875 – Mrs Whistler retires to Hastings. Paints nocturnes of Cremorne Gardens in Chelsea, including *Nocturne in Black and Gold: The Falling Rocket*, exhibited at the Dudley Gallery in November.

1877 – Completes the Peacock Room for F.R. Leyland, which Whistler calls *Harmony in Blue and Gold*. Sues Ruskin for libel in respect of his criticism of *The Falling Rocket* when it is exhibited at the Grosvenor Gallery.

1878 – Moves to the White House, Tite Street, Chelsea. Awarded a farthing's damages without costs in his libel action against Ruskin. Publishes *Whistler v. Ruskin. Art & Art Critics*.

1879 – Meets Walter Sickert. Maud gives birth to Maud McNeill Whistler Franklin. Auction sale of Whistler's possessions. Declared bankrupt. Bailiffs take possession of the White House, which is then sold to Harry Quilter. Leaves for Venice with Maud, having received a commission from the Fine Art Society for twelve etchings.

1880 – Sale of his effects at Sotheby's. Returns to London. Introduced to Théodore Duret by Manet.

1881 – Mother dies. Paints seascapes in Jersey and Guernsey. Leases flat and studio at 13 Tite Street. Association with Oscar Wilde.

1882 – Portrait of Lady Meux and three Venice etchings exhibited at the Salon. Walter Sickert leaves the

Slade School of Art to become Whistler's pupil and assistant.

1883 – Portrait of his mother is awarded a third-class medal at the Salon, and enthusiastically reviewed by Duret. Paintings exhibited at the Galerie Georges Petit. Visits Paris and paints oils and watercolours in Holland.

1884 – At St Ives, Cornwall, with pupils Mortimer Menpes and Sickert, painting small seascapes. First exhibition with the Société des Vingt (XX), Brussels. Works in Holland around Dordrecht. Exhibits portraits of Cicely Alexander and Carlyle at the Salon. One-man exhibition, *Notes – Harmonies – Nocturnes*, opens at Dowdeswell's Gallery, London. Meets Joseph Pennell, his future biographer. Leases studio at 454A Fulham Road. Elected member of the Society of British Artists.

1885 – Delivers the 'Ten O'Clock' lecture in Princes Hall, London, and later at Oxford and Cambridge. Portraits of Lady Archibald Campbell and Duret exhibited at the Salon. Visits Belgium and Holland.

1886 – Set of *Twenty-Six Etchings of Venice* issued by Dowdeswell's in London. Second one-man exhibition, *Notes – Harmonies – Nocturnes*, at Dowdeswell's. Elected President of the Society of British Artists. Exhibits portrait of Pablo de Sarasate at the Paris Salon and in Brussels.

1887 – Oils, watercolours and pastels shown at the Galerie Georges Petit in Paris. The Society of British Artists receives a Royal Charter, becoming the Royal Society of British Artists (RBA). Visits Holland and Belgium with Dr and Mrs William Whistler.

1888 – Exhibits nocturnes, etchings and drawings at the Galerie Durand-Ruel in Paris. Resigns as President of the RBA. Introduced by Monet to Stéphane Mallarmé, who translates the 'Ten O'Clock' lecture into French. Moves to the Tower House, Tite Street. Sends oils and a group of watercolours, pastels and etchings to the third Internationale Kunst-Ausstellung in Munich, and is awarded a second-class medal.

Marries Beatrice Godwin, widow of E.W. Godwin; working honeymoon in France.

1889 – Big exhibition of his work held at Wunderlich's in New York. Banquet for Whistler in Paris is followed by a dinner in London to celebrate the award of a first-class medal at Munich and the Cross of St Michael of Bavaria. Makes etchings and watercolours in Amsterdam. Awarded gold medal at the International Exhibition in Amsterdam. Made Chevalier of the Légion d'Honneur.

1890 – Moves to 21 Cheyne Walk. Meets C.L. Freer of Detroit, who forms a major collection of Whistler's work. Exhibits at Paris Salon and Brussels Salon. *The Gentle Art of Making Enemies* is published in London by Heinemann.

1891 – The Corporation of Glasgow buys the portrait of Carlyle. Portrait of his mother bought for the Musée du Luxembourg.

1892 – Important retrospective exhibition, *Nocturnes, Marines & Chevalet Pieces*, at the Goupil Gallery in London. Moves to a house at 110 rue du Bac, Paris. Made Officier of the Légion d'Honneur.

1893 – Works in Paris and Brittany on lithography, drawings and watercolours. Exhibits in 63rd exhibition of the Pennsylvania Academy of the Fine Arts.

1894 – Shows in international exhibitions in Hamburg and Antwerp, and the Société Nationale des Beaux-Arts, Paris. Portrait of Lady Archibald Campbell bought for Wilstach Collection, Philadelphia.

1895 – Sir William Eden brings an action against Whistler for not handing over the portrait of Lady Eden. Judgement goes against Whistler. Works in Lyme Regis.

1896 – Stays in Savoy Hotel and works on lithographs of Thames and portraits. John Singer Sargent lends him his studio. Takes studio in Fitzroy Street. Moves to St Jude's Cottage on Hampstead Heath. Death of wife, Beatrice. He adopts his sister-in-law Rosalind Birnie Philip as his ward, and makes her his executrix. Goes to Honfleur, Dieppe and Calais.

1897 – Supports Pennell in his successful libel action against Sickert for claiming transfer lithographs are not true lithography. In Dieppe with Pennell and E.G. Kennedy. Appeal in the Eden case heard in Paris and is decided in Whistler's favour.

1898 – Elected President of the International Society of Sculptors, Painters and Gravers. Opening of Académie Carmen, Paris. Death of Mallarmé.

1899 – Visits Italy for the marriage of William Heinemann. His account of the Eden case, *Eden versus Whistler: The Baronet and the Butterfly*, is published in Paris. Exhibits in first *World of Art Exhibition*, St Petersburg.

1900 – Death of brother William. Heinemann asks the Pennells to write the authorised life of Whistler. Visits Holland and then joins the Birnie Philips near Dublin for three weeks. Very ill in Marseilles; sails for Corsica. Closure of Académie Carmen.

1901 – Closes studio in Paris and sells 110 rue du Bac. Convalesces in Bath with the Birnie Philips.

1902 – Leases 74 Cheyne Walk from the architect C.R. Ashbee and lives there with the Birnie Philips. Holidays with Freer in The Hague, but becomes seriously ill. Visits Scheveningen, the Mauritshuis and galleries at Haarlem.

1903 – Receives honorary degree of Doctor of Laws from the University of Glasgow but too ill to attend the ceremony. Dies on 17 July. Buried in Chiswick Cemetery.

1904 – Memorial exhibition of his work in Boston, organised by Copley Society.

1905 – Memorial exhibition, *Paintings, Drawings, Etchings and Lithographs*, organised by the International Society in London, and *Oeuvres de James McNeill Whistler* in the Ecole des Beaux-Arts in Paris.

Notes

For additional information on Whistler's oil paintings, water-colours and drawings, etchings and lithographs cited in the text, see the standard catalogues marked * in the Bibliography.

Chapter One: Difference

1 For Whistler's 'Ten O'Clock' lecture see James McNeill Whistler, *The Gentle Art of Making Enemies*, London 1892, pp.131–59 (hereafter *Gentle Art*).

2 Quoted in Richard Emmons, *The Life and Opinions of Walter Richard Sickert*, London 1941, p.42.

3 *Gentle Art*, pp.177–9.

4 Frank Harris, 'Whistler: Artist and Fighter', *Contemporary Portraits*, New York 1915, pp.66–96.

5 E.R. and J. Pennell, *The Life of James McNeill Whistler*, 2 vols., London and Philadelphia 1908, II, p.217.

6 Richard Dorment, Margaret F. MacDonald et al., *James McNeill Whistler*, exh. cat., Tate Gallery, London 1994.

7 *Gentle Art*, pp.126–8.

8 *Gentle Art*, p.171.

9 *Gentle Art*, p.17.

10 *Gentle Art*, p.99.

11 Ernst Gombrich, *On Pride and Prejudice in the Arts*, Pentagram Papers 26, London 1997.

12 Linda Merrill, *A Pot of Paint: Aesthetics on Trial in Whistler v. Ruskin*, Washington, DC and London 1992, p.151.

13 Merrill, *A Pot of Paint*, p.101.

14 The statement concerning the rejuvenation of Western art by Oriental art was made by Ralph Curtis, an American friend of Whistler's, and quoted by Pennell, *Life*, I, p.174. For a contemporary analysis of Japanese design principles see John Leighton, 'On Japanese Art: A Discourse Delivered at The Royal Institution of Great Britain, May 1, 1863', reprinted in Elizabeth Holt (ed.), *The Art of All Nations 1850–1873*, New York 1981, pp.364–77.

15 In the Whistler exhibition at the Nationalgalerie, Berlin in October 1969, Helen Frankenthaler described for me how much Whistler's painting technique meant to her and her American painter friends, including Morris Louis.

16 Quoted in Alastair Grieve, *Whistler's Venice*, New Haven and London 2000, p.195.

17 For Wagner's 'The Art-Work of the Future' see Charles Harrison, Paul Wood and Jason Geiger (eds.), *Art in Theory 1815–1900*, Oxford 1998, pp.471–8. The account of Whistler decorating the floor of his house is by Mrs Richmond Ritchie, in an undated letter to Joseph Pennell, in the E.R. and J. Pennell Collection of Whistler Manuscripts, Library of Congress, Washington, DC.

18 Linda Merrill, *The Peacock Room: A Cultural Biography*, Washington, DC, New Haven and London 1998, pp.142–3. Whistler's statement to Bacher, quoted by Merrill, is in Otto H. Bacher, *With Whistler in Venice*, New York 1906, pp.58–9.

19 *With Kindest Regards: The Correspondence of Charles Lang Freer and James McNeill Whistler 1890–1903*, ed. Linda Merrill, Washington, DC and London 1995. Whistler's letter to Freer of 1899 is quoted on pp.122–4.

Chapter Two: Likeness

1 In addition to the standard biographical sources, the material in this chapter about Whistler's early life and ancestry is drawn from material in my articles 'Whistler's Early Relations with Britain and the Significance of Industry and Commerce for his Art. Parts I and II', *Burlington Magazine*, vol.36, Apr. and Oct. 1994, pp.212–24, 644–74.

2 For Whistler's early life in Russia see Albert C. Parry, *Whistler's Father*, New York 1939.

3 For Whistler and Haden and their relationship as etchers see Katharine A. Lochnan, *The Etchings of James McNeill Whistler*, New Haven and London 1984.

4 For the 'French Set' see Lochnan, *Etchings of Whistler*.

5 Pennell, *Life*, I, p.81.

6 For further information about *The White Girl*, with a suggestion as to why the Royal Academy rejected it in 1862, see my essay 'Whistler's "The White Girl": Painting, Poetry and Meaning', *Burlington Magazine*, vol.140, May 1998, pp.300–11.

7 For Gambart as a dealer and his relationship with Alma-Tadema, Rosa Bonheur, Frith, Holman Hunt and many others, see Jeremy Maas, *Gambart: Prince of the Victorian Art World*, London 1975.

8 For Fantin-Latour's group portraits see Douglas Druick and Michel Hoog, *Fantin-Latour*, exh. cat., National Gallery of Canada, Ottawa 1983.

9 For Rossetti see Alastair Grieve, 'Rossetti and the Scandal of Art for Art's Sake in the Early 1860s', in Elizabeth Prettejohn (ed.), *After the Pre-Raphaelites*, Manchester 1999. For Rossetti's reputation as an artist in Paris and London and his relationship with French and English artists at this time see my article 'Manet, Rossetti, London and Derby Day', *Burlington Magazine*, vol.133, Apr. 1991, pp.228–36.

10 W. Bürger [Théophile Thoré], *Salons de W. Bürger, 1861 à 1868*, Paris 1870, I, p.420.

Chapter Three: Modernity

1 For Baudelaire's article, which praises Whistler's Thames etchings, and his Salon review of 1859, see *Baudelaire: Art in Paris 1845–1862*, trans. and ed. Jonathan Mayne, London 1965, pp.154–216, 217–22. For the Thames etchings see Lochnan, *Etchings of Whistler*.

2 For the bal Bullier see Henri d'Alméras, *La Vie Parisienne sous le Second Empire*, Paris 1923.

3 For Baudelaire's Salon review of 1846 see *Baudelaire: Art in Paris*, pp.41–120. The material on Baudelaire, Swinburne and Ruskin in this chapter is based on my essay 'Whistler, Swinburne and art for art's sake', in Prettejohn (ed.), *After the Pre-Raphaelites*, pp.58–89.

4 'The works of Edgar Allan Poe influenced Whistler immensely. His essays and writings benefited enormously by his contact [*sic*] with that clever man' (Mortimer Menpes, *Whistler as I Knew Him*, London 1904, p.65).

5 For a translation of Whistler's letter to Fantin-Latour see Robin Spencer, *Whistler: A Retrospective*, New York 1989, pp.82–4. For Albert Moore see Robyn Asleson, *Albert Moore*, London 2000.

6 Swinburne's review of Whistler's 'Ten O'Clock' was published in the *Fortnightly Review*, June 1888. For further information, and Whistler's response to it, see Ch.5, n.9.

7 Pennell, *Life*, I, p.189.

8 Quoted in Donald J. Olsen, *The Growth of Victorian London*, London 1976, p.107. See also David Owen, *Victorian London 1855–1898*, Cambridge, Mass. and London 1982.

9 A quantity of material and documentation relating to Cremorne Gardens is in Chelsea Reference Library, London. See Lynda Nead, *Modern Babylon*, New Haven and London 2000. The quotations from the Ruskin trial are in Merrill, *A Pot of Paint*.

10 For Maud Franklin and contemporary fashions see Margaret F. MacDonald, 'Maud Franklin', in Ruth E. Fine (ed.), *James McNeill Whistler: A Re-examination*, Studies in the History of Art, vol.19, National Gallery of Art, Washington, DC 1987, pp.13–26.

11 Merrill, *The Peacock Room*, passim.

12 For Frith's anecdote about *Derby Day* see W.P. Frith, *Further Reminiscences*, London 1888, p.157. Whistler's letter to his solicitor, James Anderson Rose, is quoted in Merrill, *A Pot of Paint*, p.84.

13 For a richly illustrated account of Victorian artists and their studios see Jeremy Maas, *The Victorian Art World in Photographs*, London 1984.

Chapter Four: Morality

1 Most of the documents cited in this chapter are quoted in Merrill, *A Pot of Paint*, but the interpretation put on the events is very different from the one presented here.

2 For the economic argument in this chapter I am much indebted to James Clark Sherburne, *John Ruskin or the Ambiguities of Abundance: A Study in Social and Economic Criticism*, Cambridge, Mass. 1972.

3 For Whistler's comments on the time Hunt took to paint his picture see E.R. and J. Pennell, *The Whistler Journal*, Philadelphia 1921, p.26.

4 *Notes by Mr. Ruskin. Part I: On His Drawings by the late J.M.W. Turner. Part II: On his Own Handiwork Illustrative of Turner*, revised ed., The Fine Art Society, London 1878, pp.29, 35, 123–4.

5 'Epilogue', dated 10 May 1878, *Notes by Mr Ruskin* pp.71–8.

6 For the testimonies of the witnesses at the trial see Merrill, *A Pot of Paint*.

7 Linda M. Austin, *The Practical Ruskin: Economics and Audience in the Late Work*, Baltimore 1991.

8 Whistler, *Whistler v. Ruskin. Art & Art Critics*, Chatto & Windus, London, printed by Thomas Way, signed and dated 'J.A.McN. Whistler, The White House, Chelsea, December 24, 1878'; reprinted in *Gentle Art*, pp.19–34.

9 *R.B. Kitaj*, London, Tate Gallery 1994 (Exhibition Guide).

Chapter Five: Performance

1 Pennell, *Life*, I, p.186; Grieve, *Whistler's Venice*, pp.166–7.

2 Menpes, *Whistler as I Knew Him*, pp.115–24.

3 *Lady's Pictorial*, 24 Feb. 1883, quoted in Spencer, *Whistler: A Retrospective*, p.198.

4 Pennell, *Life*, I, p.293.

5 *Gentle Art*, pp.115–16.

6 Whistler's letter to Théodore Duret is in the Pennell Collection of Whistler Manuscripts, Library of Congress, Washington, DC. Duret's article on Whistler was published in the *Gazette des Beaux Arts*, vol.23, Apr. 1881, pp.364–9; reprinted in Théodore Duret, *Critique d'Avant-garde*, Paris 1885, pp.252–3. A translation is in Spencer, *Whistler: A Retrospective*, pp.180–2, 197.

7 *Gentle Art*, p.66.

8 Richard Ellmann (ed.), *The Artist as Critic: Critical Writings of Oscar Wilde*, London 1970, p.15. Whistler's annotated response to Wilde's criticism, and their ensuing correspondence, published in the *World* is reprinted in Whistler, *Gentle Art*, pp.161–3, immediately following the 'Ten O'Clock', pp.131–59.

9 Whistler reprints an abbreviated, annotated version of Swinburne's review, first published in *Fortnightly Review*, June 1888, as 'An Apostasy', in *Gentle Art*, pp.250–8. Whistler's letter to Swinburne of 3 June 1888, published in the *World*, and his final word, 'Et tu, Brute', are both in *Gentle Art*, pp.259–62. For further details concerning their agreements and disagreements

and its context see my essay 'Whistler, Swinburne and art for art's sake'.

10 For Mallarmé's poem and Whistler's eulogy on Mallarmé in the *Whirlwind* see *Correspondance Mallarmé–Whistler*, ed. C.P. Barbier, Paris 1964, p.75. For further information on their collaboration see Katharine A. Lochnan, '1887–1894: Return to Lithography', in Harriet K. Stratis and Martha Tedeschi (eds.) *The Lithographs of James McNeill Whistler*, 2 vols., Chicago 1998, I, pp.104–7.

11 For Whistler's letter to Mallarmé of 1896 concerning Poe see *Correspondance Mallarmé–Whistler*, p.257; translation in Spencer, *Whistler: A Retrospective*, p.302.

12 Théodore Duret, *Whistler*, London 1917, p.84. For this and other contemporary reactions to Whistler's portrait of Mallarmé see Lochnan, '1887–1894: Return to Lithography', pp.106–7.

13 Montesquiou's poem 'Moth', composed to celebrate the purchase of Whistler's portrait of his mother by the French government, is in his *Chauves-Souris*, Paris 1893. For the poem and the relationship of Whistler and Montesquiou see *La Chauve-Souris et le Papillon: Correspondance Montesquiou–Whistler*, ed. Joy Newton, Glasgow 1990.

14 A translation of Mallarmé's tribute to Whistler is in Spencer, *Whistler: A Retrospective*, p.303.

15 Menpes, *Whistler as I Knew Him*, pp.79–82. For Whistler's visit to The Hague in 1902 and his reactions to Rembrandt and Hals see Pennell, *Life*, II, pp.282–7.

16 *Baudelaire: Art in Paris, 1845–1862*, pp.152–5.

17 For the reception of Fauvism in 1905 see Roger Benjamin,

'Fauves in the Landscape of Criticism', in Judi Freeman (ed.), *The Fauve Landscape*, exh. cat., Los Angeles County Museum of Art and New York 1990, pp.241–66. For Whistler in 1905, viewed from the perspective of the 1890s, see in particular Maurice Denis, 'De Gauguin, de Whistler et de l'excès des théories', *Théories*, 1912 [reprinted 1920], pp.199–210, reprinted in Denis, *Le ciel et l'Arcadie*, ed. Jean-Paul Bouillon, Paris 1993, pp.84–99.

18 For Proust's letter about Whistler and Ruskin to Marie Nordlinger of 8 or 9 Feb. 1905, see Marcel Proust, *Correspondance*, ed. Philip Kolb, Paris 1905, V, pp.41–2, translated in Spencer, *Whistler: A Retrospective*, p.364. Ezra Pound's 'Patria Mia', *The New Age*, vol.11, 24 Oct. 1912, pp.611–12, is also reprinted in Spencer, *Whistler: A Retrospective*, pp.367–8. For a gendered interpretation of Pound's self portrait photograph as Whistler's *Carlyle* see Andrew Stephenson, 'Refashioning modern masculinity: Whistler, aestheticism and national identity', in David Peters Corbett and Lara Perry (eds.), *English Art 1860–1914: Modern Artists and Identity*, Manchester 2000, pp.133–49. The Tate Gallery exhibition of Whistler was *Loan Collection of Works by James McNeill Whistler*, Room V, July–October 1912. It consisted mainly of works owned by Rosalind Birnie Philip which she subsequently gifted and bequeathed to Glasgow University.

* denotes standard oeuvre catalogue

Otto Bacher, *With Whistler in Venice*, New York 1908

David Park Curry, *James McNeill Whistler at the Freer Gallery of Art*, exh. cat., New York and London 1984

Eric Denker, *In Pursuit of the Butterfly. Portraits of James McNeill Whistler*, Seattle and London 1995

Richard Dorment and Margaret MacDonald, *James McNeill Whistler*, exh.cat., Tate Gallery, London 1995

Théodore Duret, *Histoire de James McNeill Whistler et de son oeuvre*, Paris 1904 (English trans. Philadelphia and London 1917)

Ruth E. Fine (ed.), *James McNeill Whistler. A Re-examination*, Studies in the History of Art, vol.19, Washington 1987

Robert H. Getscher and Paul G. Marks, *James McNeill Whistler and John Singer Sargent, Two Annotated Bibliographies*, New York and London 1986

Alastair Grieve, *Whistler's Venice*, New Haven and London 2000

* Edward G. Kennedy, *The Etched Work of Whistler. Illustrated by Reproductions in Collotype of the Different States of the Plates*, revised ed., San Francisco 1987

Katharine A. Lochnan, *The Etchings of James McNeill Whistler*, New Haven and London 1984

Margaret F. MacDonald, Grace Galassi, Aileen Ribeiro, and Patricia De Montfort, *Whistler, Women and Fashion*, exh.cat., The Frick Collection, New Haven and London 2003

* Margaret F. MacDonald, *James McNeill Whistler. Drawings, Pastels, and Watercolours*, New Haven and London 1995

Mortimer Menpes, *Whistler As I Knew Him*, London 1904

Linda Merrill, *A Pot of Paint. Aesthetics on Trial in Whistler v.*

Ruskin, Washington 1992

Linda Merrill, *The Peacock Room. A Cultural Biography*, New Haven and London 1998

Edgar Munhall, *Whistler and Montesquiou: The Butterfly and the Bat*, New York and Paris 1995

Joy Newton (ed.), *La Chauve-Souris et le Papillon. Correspondance Montesquiou–Whistler*, Glasgow 1990

E.R. and J. Pennell, *The Life of James McNeill Whistler*, revised ed., London and Philadelphia 1911; (French ed., Paris 1913)

E.R. and J. Pennell, *The Whistler Journal*, Philadelphia 1921

Elizabeth Prettejohn (ed.), *After the Pre-Raphaelites*, Manchester 1999

W. Graham Robertson, *Time Was*, London 1931, 1981

Robert Rosenblum, and MaryAnne Stevens, 1900 *Art at the Crossroads*, exh. cat., Royal Academy, London 2000

John Ruskin, *The Works of John Ruskin*, E.T. Cook and A. Wedderburn (eds.) 39 vols., London 1903–12

James Clark Sherburne, *John Ruskin or the Ambiguities of Abundance*, Cambridge, Mass. 1972

Robin Spencer, *Whistler A Retrospective*, New York 1989

Robin Spencer, 'James McNeill Whistler', *New Dictionary of National Biography*, Oxford 2003

* Harriet K. Stratis and Martha Tedeschi (eds.) *The Lithographs of James McNeill Whistler*, 2 vols., Chicago 1998

T.R. Way, *Memories of James McNeill Whistler*, London and New York 1912

James McNeill Whistler, *The Gentle Art of Making Enemies*, revised ed., London and New York 1892

James McNeill Whistler, *Eden versus Whistler: The Baronet and the Butterfly. A Valentine with a Verdict*, Paris and New York 1899

Andrew Wilton and Robert Upstone, *The Age of Rossetti, Burne-Jones & Watts. Symbolism in Britain 1860–1910*, exh.cat., Tate Gallery, London 1997

* Andrew McLaren Young, Margaret MacDonald, Robin Spencer and Hamish Miles, *The Paintings of James McNeill Whistler*, 2 vols., New Haven and London 1980

Whistler On-Line

Whistler's Art:

www.huntsearch.gla.ac.uk/whistler/ (over 3,000 annotated entries with over 800 images from the Hunterian Art Gallery, Glasgow University)

Whistler's Correspondence:

www.whistler.gla.ac.uk/ correspondence

Photographic Credits

Copyright Credits